IMAGES
of America

HAVRE DE GRACE

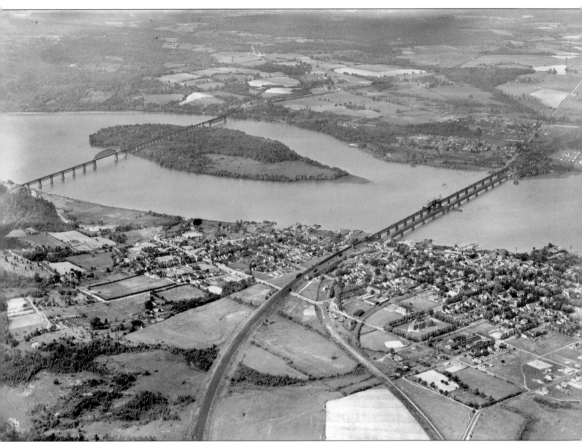

AERIAL PHOTOGRAPH OF HAVRE DE GRACE, JUNE 23, 1927. This was Havre de Grace on the eve of great change. Since at least the 1650s and perhaps earlier, folks here lived off the riches of the Susquehanna, overflowing with herring and shad for canneries that lined the banks; providing water for the surrounding farms; churning the sediment to enrich the celery grasses that fed and housed countless numbers of waterfowl, ducks, and geese for meat that was shipped all over the East Coast; and luring tourists for the spectacular view and the bounteous hunting and fishing. All that would end, however, with the 1927 opening of the great, water-driven power plant being built upriver, the Conowingo Dam, and the restricted flow of water it would bring. Note Revolution Street in the lower right of the photograph. It brought Route 40 drivers in from Baltimore, along Union Avenue, and over the river to Perryville via the double-decker bridge, which ran to the right of the Pennsylvania Railroad Bridge in the middle right of the photograph. (Courtesy Hagley Museum and Library.)

ON THE COVER: Descendants of John O'Neill stand on either side of the stone monument that holds a cannon similar to the one used by O'Neill to hold off the British as they landed in Havre de Grace on May 3, 1813. Although most of the ragtag defenders of the town ran into the hills along with the women and children who could get away, O'Neill and a handful of others held out with three small cannons until O'Neill stood alone in the street facing the redcoats and was captured. He was released several days later, possibly at the pleading of his daughter, and became the town's great hero. He was awarded with the post of lighthouse keeper, a post which at least one member of his family held for five generations. Esther Jackson is on the left in this photograph of the monument's unveiling in 1914; Naomi Tydings is on the right of the monument. (Courtesy Ellsworth and Madelyn Shank.)

IMAGES
of America

HAVRE DE GRACE

Bill Bates

ARCADIA
PUBLISHING

Published by Arcadia Publishing
Charleston SC, Chicago IL, Portsmouth NH, San Francisco CA

Printed in the United States of America

Library of Congress Catalog Card Number: 2006924937

For all general information contact Arcadia Publishing at:
Telephone 843-853-2070
Fax 843-853-0044
E-mail sales@arcadiapublishing.com
For customer service and orders:
Toll-Free 1-888-313-2665

Visit us on the Internet at www.arcadiapublishing.com

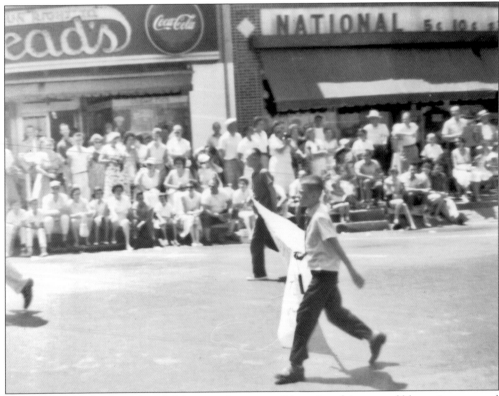

BOYS MARCHING IN PARADE. Celebrating the sweep of American history and liberty is an annual ritual done with much pride in the Havre de Grace Fourth of July parade. In the background is Read's Drug Store, which was housed in what is one of the few remaining structures that survived the burning of Havre de Grace in 1813, the Rodgers House. The house has been gutted, altered, and repurposed many times over its history, and it stands as a reflection of the changes the town has seen in the past 200-plus years. (Courtesy Brenda Baker.)

CONTENTS

ACKNOWLEDGMENTS

This is a book of Havre de Grace memories. Many of the longtime residents who have shared their memories with me are well-known, well-respected, and highly knowledgeable; some are all three. They are young, such as Charlie Bomboy, 27, and they are young-at-heart, such as Carrie Lawrence, 98.

Each photograph I have selected for this book—from the hundreds I uncovered or that were offered to me—is unique. Each shared memory is unique as well, opening up a Havre de Grace of the past, a Havre de Grace of the mind, over 120 years of Havre de Grace history as viewed from 204 different angles—the number of photographs herein. Folks I couldn't have done it without you: Brenda Baker, Bernie Bodt, Charlie Bomboy, Kathy Bomboy, Kristy Breslin, Joe Carr, Kathy Casey, Dennis Caudill, Jim Chrismer, Joe Cook, David Craig, Beth and Bill Cyr, George Deibel, Pat Donovan, Capt. Sharon Duncan, Rev. John Elledge, Mindy Elledge, Jim Elliott, Grace Fielder, Rebecca Fitzgerald, Richard Flint, Heidi Goll, Ann Green, Brenda Guldenzopf, Betsy Lee Hacke, Barbara Hall, Dawn Hamilton, Richard Herbig, Glenn Higgins, Rita Ingram, Irna and Peter Jay, Bob Jobes, Walter Johnson, Fran Johnston, Margaret Jones, Jim Kropp, Nikki Languis, Carrie Lawrence, Bob Lidke, Richard Long, Bill McIntyre, Jack McLaughlin, Pat Mergler, R. Madison Mitchell Jr., John Muldoon, Lois Nagle, Terry Noye, Wendy Osborne, Judy Plitt, Bill Price, Pete Riecks, Nancy Robinson, Wini Roche, David Seibert, Audrey Sellars, Ellsworth and Madelyn Shank, Richard Sherrill, Debbie and Paul Shertz, Maryanna Skowronski, Joe Swisher, Richard Tome, Cathy Vincenti, Pat Vincenti, Peter Wakefield, Caleb Walton, and James Wollon. The staff and volunteers at these organizations help to keep Harford County History alive and well: Bel Air Book Festival, Hagley Museum and Library, Harford County Public Library, Havre de Grace Decoy Museum, Havre de Grace Visitors Center, Historical Society of Harford County, Lighthouse Keepers Museum, Maritime Museum, and Susquehanna Museum. I also thank Lauren Bobier, my editor at Arcadia Publishing, and my wife, Mary Ellen, and children, Geoffrey and Emily.

This book is dedicated to two men who died during the making of this book: Tom Chambers and Sammy Magness. Each helped to document Harford County history, Tom at the Historical Society of Harford County and in his many poems, and Sammy with his camera always at the ready in his hometown of Havre de Grace. Each man overcame great odds, making the most of the hand he was dealt. Each one looked for the good in others and brought many people together. The parade is over; the parade continues on.

INTRODUCTION

The earliest record of the natural resources of the Havre de Grace area was made by the English explorer Capt. John Smith (of Pocahontas fame) in 1608. He sailed with a dozen men into the upper Chesapeake Bay and mapped its tributaries. He noted that the ducks were so thick in the air that he brought down 148 of the fowl with just three blasts of his shotgun. He said that the fish seemed to be piled upon each other in the Susquehanna River. He was a one-man tourism council. Until the creation of the Conowingo Dam in 1927, fortunes were made on sea and land by fishing and processing and farming and canning. The homes of yesterday's magnates are lavish bed and breakfast inns today.

Revolutionary War days saw the forefathers making Havre de Grace a frequent stop in their travels. Thomas Jefferson visited John Adlum at Swan Harbor Farm, which is a county-owned facility today. The city was like a second home to Marie Jean Paul Joseph Roche Yves Gilbert du Motier, known to Americans as the Marquis de Lafayette, or simply Lafayette. During the Civil War, horses and trains brought troops of many states through the Unionist town. From 1912 to 1950, jockeys rode horses to victory at the Havre de Grace Race Track (called "the Graw" by New Yorkers, to the consternation of locals). All five brothers in the local Mergler family were jockeys—their dad was a famous horse trainer. The track brought the well-to-do and the ne'er-do-wells from New York and New Jersey. Prohibition kept some gin-making families out of the poorhouse.

The city's longtime residents tell the fast-fading tales of ethnic neighborhoods that joined together to defeat the Ku Klux Klan and summer days when the kids jumped off the railroad bridge to swim in the Susquehanna and winter tales of skating on the frozen river. Havre de Grace's homes, churches, and schools reflect the strong ties to family and faith that residents have maintained through the centuries. A commitment to service is also found in the small city's five volunteer fire companies and many service organizations that keep the community safe and responsive to needs.

As Havre de Grace makes the transition from a small town to a tourist and retirement destination, the town keeps redefining its needs. The late mayor, Frank Hutchins, led the seemingly hopeless task of bringing beauty to the sidewalks one planter at a time. From those beginnings, landscaping and new parks and streetscaping enhanced the town's attractiveness. The construction of golf courses, executive developments, and waterside condos, along with the gentrification of older neighborhoods, is challenging the city to define its character soon or perhaps lose what makes it unique in the county.

As the photographs in this book reveal, Havre de Grace architecture is a unique mix of styles, from Revolutionary to Victorian to art deco. Havre de Grace residents are a plucky mix too of Italian, Irish, African American, and other backgrounds, all with a strong work ethic. Beautiful as it is, Havre de Grace is far more than just a quaint little town. After all, George Washington walked these streets, and so too have generations of everyday heroes who kept this city alive through fire and flood at the risk of their lives and fortunes.

A note on dating the photographs: where documentation exists, I have included the date in the boldface title of the photograph caption. Otherwise, in the text of the caption, I mention possible dating according to evidence in the photographs or from other records.

Your corrections, stories, or comments are welcome. Please visit the Web site that complements this book at http://www.harfordbooks.com.

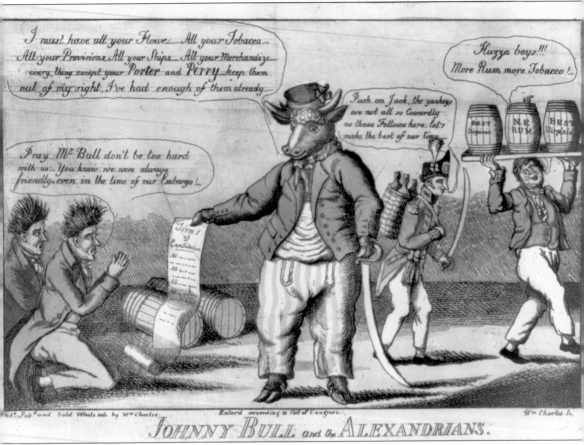

JOHN BULL AND THE ALEXANDRIANS. This drawing portrays the British (symbolized by the cartoon character John Bull) easily having their way with the small town of Alexandria, Virginia. The British came to expect these minor victories, similar to this contemporary account of the easy defeat of Havre de Grace: "At day break, on the third of May, the drums beat an alarm, and a discharge of cannon immediately followed. At that moment were seen twenty barges filled with the enemy, advancing rapidly towards the town. . . . The women and children fled in every direction to the neighboring hills and woods. The militia were called to their arms with all possible speed, but in such a state of confusion, that they could not be rallied. Congreve rockets began to be thrown from the barges, the threatening appearance of which produced a still greater agitation, and when one of the militia was killed by a rocket, it was a signal for a general retreat." (Courtesy Library of Congress.)

One

A CITY IN THE MAKING

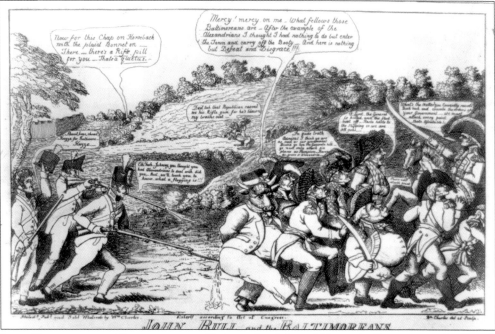

JOHN BULL AND THE BALTIMOREANS. Perhaps the defeat of Havre de Grace set up the British for their huge loss at Baltimore. They certainly didn't like being dealt the same harshness as they showed to Havre de Grace: "The sun had scarcely risen, when all the enemy's forces were landed, and marched to an open square in the centre of the town. They were here separated into bands of thirty or forty each, and sent to plunder and burn such houses as were not already on fire. . . . Their manner was, on entering a house, to plunder it of such articles as could be of any service to them, and easily transported, and convey them to their barges. Every man had his hatchet in his girdle, and when wardrobes and bureaus happened to be locked, they were made to yield to the force of this instrument. This was not a work of much time, and as soon as it was accomplished, they set fire to the house, and entered another for the same purposes." (Courtesy Library of Congress.)

9

DETAIL OF HARDUCOEUR'S MAP OF THE AREA OF THE CHESAPEAKE BAY AND SUSQUEHANNA RIVER, 1799. This map has given rise to rumors (call them rural versus urban legends) that Havre de Grace at one time had a college and other features it never had. The reason is that the surveyor shows what existed in 1799, designated by him as being inside the thin line showing the "Limits of the Old Town," and what his imagination supposed could be developed on still-virgin land. It would have made a town to rival London itself in size and scope, according to another hopeful developer of the period. Notice the "Road from Baltimore" in the upper left. This is the Old Post Road, the mail route that linked the major cities and towns of the East. It would later become known as Route 40. (Courtesy Jim Wollon.)

10

SIGN, GEORGE WASHINGTON TRAVELED THIS ROAD. General Washington, Thomas Jefferson, the Marquis de Lafayette, and hundreds of their troops walked the streets of town and crossed the Susquehanna by way of its ferry. In fact, before the town was named Havre de Grace, it was called Susquehanna Lower Ferry. (The Upper Ferry was at Lapidum.) Washington frequently traveled the Old Post Road to Philadelphia. Signs like this are posted along the way. (Courtesy Jim Wollon.)

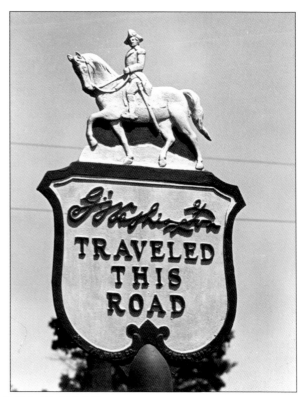

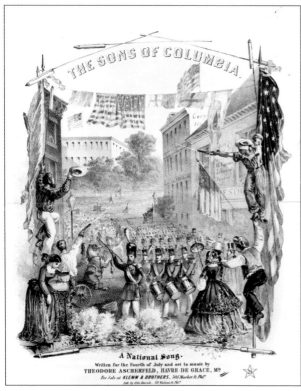

SHEET MUSIC, "THE SONS OF COLUMBIA, A NATIONAL SONG." Havre de Grace's Theodore Ascherfeld must have had his share of fame with this song composed to celebrate the Fourth of July. The cover shows soldiers on parade, possibly in Philadelphia, with an adoring crowd shooting rockets. It is estimated to have been written between 1850 and 1880. (Courtesy Library of Congress.)

11

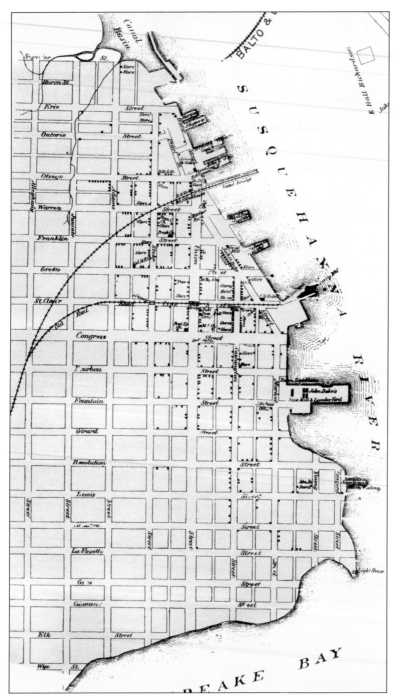

DETAIL OF MARTINET'S MAP OF HARFORD COUNTY, 1878. This highly detailed map shows where homes and businesses stood in 1878, and marked the roads and railroad lines. The roads appear mostly as they do today, except for Pennington Avenue, which was called St. Clair Street and carried an entrenched spur (locals called it "the Cut") of the main Pennsylvania line. The spur allowed trains to load by the docks and then rejoin the main line for transporting the goods. (Author's collection.)

Two

LIFE ON THE WATER I

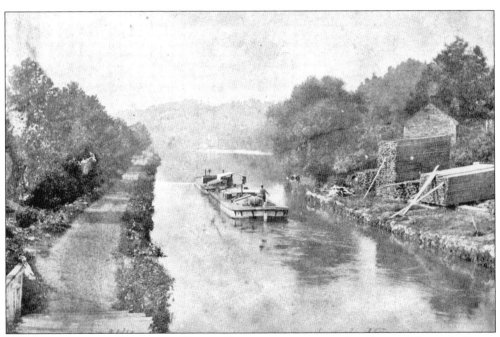

SUSQUEHANNA AND TIDEWATER CANAL. For many generations of residents of Havre de Grace, life on the water meant work—darned hard work. Sure there would be an influx of workers for harvest time—whether the harvest was fish or fruit, especially tomatoes and corn, and in an earlier time, tobacco. But this photograph of a barge carrying its cargo down the Susquehanna, as peaceful and bucolic as it seems to us today, contains all the elements of a hard life: loading and unloading cargo, keeping the barges in good repair along the way, dismantling them at the end of ride (the downstream flow only goes in one direction), tending the mules that towed the barges along the towpath (to the left in the photograph), not to mention the farming and harvesting of the crops, the mining of the coal, or the manufacturing of the items, and then transporting them to the canal. Simpler times, anyone? (Courtesy the Historical Society of Harford County, Inc.)

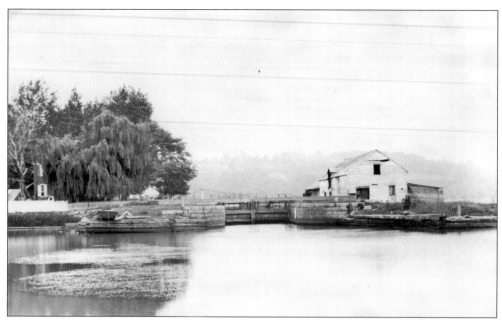

SUSQUEHANNA AND TIDEWATER CANAL LOCK HOUSE. The lock house, the house where the lock keeper lived, sits on the left, shaded by trees. The barn on the right housed mules that pulled the barges from the towpath. This was the last of 29 locks of the canal that began in Wrightsville, Pennsylvania, and eased barges full of goods downstream, avoiding the rocks and shallows in the open river. (Courtesy the Historical Society of Harford County, Inc.)

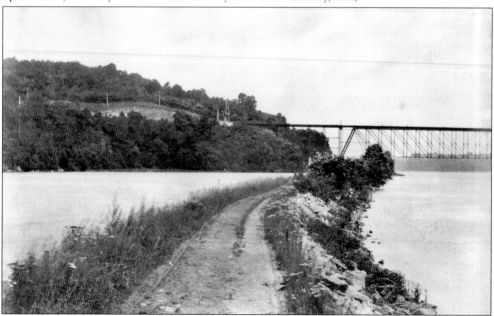

SUSQUEHANNA AND TIDEWATER CANAL TOWPATH. The 1878 Harford County Directory compares Havre de Grace's harbor favorably to Rio de Janeiro's, "the most beautiful in the world." A major port city it's not, however, because of the Susquehanna Flats, sandy deposits that built up through the years from river sediment and block major vessels from entering the river from the bay. (Courtesy the Historical Society of Harford County, Inc.)

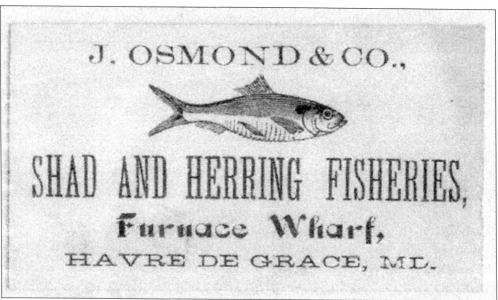

SIGN, J. OSMOND AND COMPANY, SHAD AND HERRING FISHERIES, FURNACE WHARF. The 1878 directory reads, "The shad and herring fisheries in the immediate vicinity afford employment to many. . . . During the fall and winter, quite a number of the residents are engaged in ducking, and a large revenue is derived from this source. Probably the largest business carried on here is the re-shipping of anthracite coal." (Courtesy the Historical Society of Harford County, Inc.)

HOME AND FISH SHED. More like a snowball stand than a store, and of course not like the fish sheds that hauled in herring by the thousands, the shed in this c. 1955 photograph probably belonged to a fisherman that did some business on the side. In Havre de Grace, fresh fish has always been easy to find. (Courtesy the Historical Society of Harford County, Inc.)

15

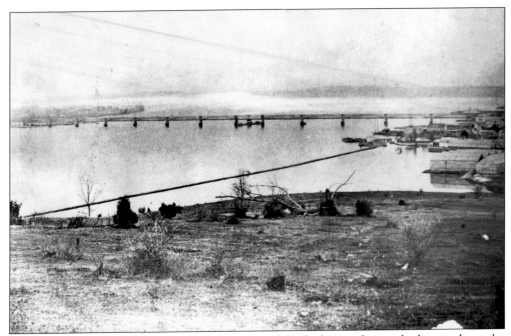

CANAL OUTLET BASIN. This area was journey's end for the barges that made the trip down the Susquehanna Canal. The huge basin was 47 acres large. It could hold up to 1,000 boats, barges, and fish sheds, some of which are visible in the lower right. (Courtesy the Historical Society of Harford County, Inc.)

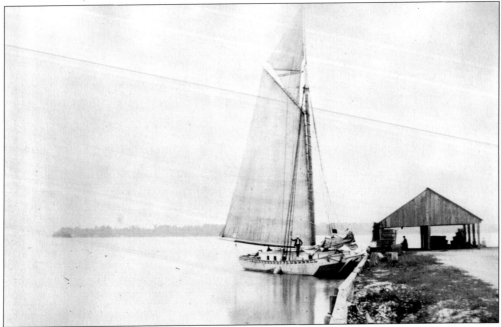

SCHOONER. This photograph of the *Elsie* was taken between 1884 and 1894. A common sight throughout the age of sailing ships and beyond, the schooner was large enough to carry freight and swift enough to get it to its destination fast—or outrun pirates trying to steal the freight. (Courtesy the Historical Society of Harford County, Inc.)

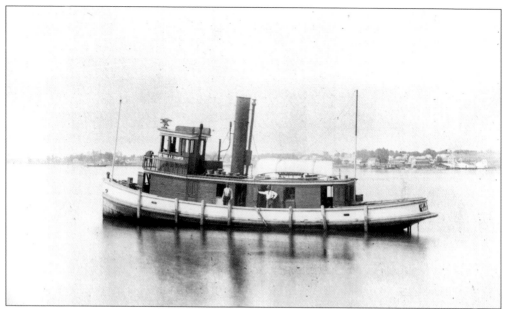

TUGBOAT. This tugboat was commanded by Capt. Thomas A. P. Champlin. The photograph was taken showing the tug's port side. Two men are on deck. This is one of many images from an album of photographs taken sometime between 1884 and 1894 and owned by Dr. Alexander Koser. More about this album appears in chapter six. (Courtesy the Historical Society of Harford County, Inc.)

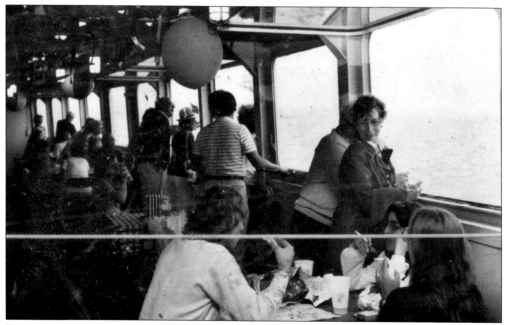

PASSENGERS ABOARD THE *LANTERN QUEEN*, SEPTEMBER 1982. Steamboats ruled the waves as a method of transporting folks in and out of Havre de Grace beginning in 1840, when the *Canton* became the first of many steamboats to make regular port calls. The *Lantern Queen*, a motorized version of a paddle-wheeled craft, takes tourists for excursions along the Susquehanna and the Bay. (Courtesy the Historical Society of Harford County, Inc.)

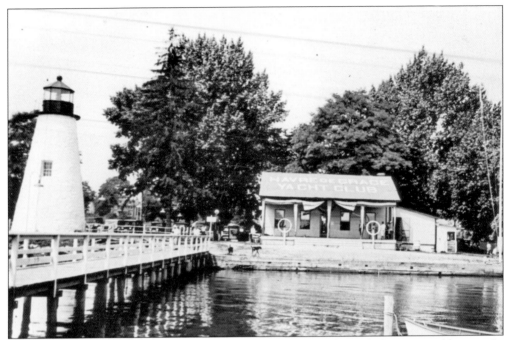

HAVRE DE GRACE YACHT CLUB, 1933. The club and the nearby yacht basin served boaters. In the early days of aviation, pilots, usually flying low and in open airplanes, had few, if any, local maps to rely upon, so names on the roofs of buildings, as pictured here, became a set of markers for pilots to know where they were. (Courtesy Glenn Higgins.)

CONCORD POINT LIGHTHOUSE. One of the most successful restoration projects in town is that of the old light keeper's house. For decades, people knew the building as a night club, the Ebb Tide, the Home Stretch, or the Light House Inn. Stripped of its additions and pared back to its (almost) original condition, the house stands again as a worthy companion to the lighthouse. (Courtesy Jim Wollon.)

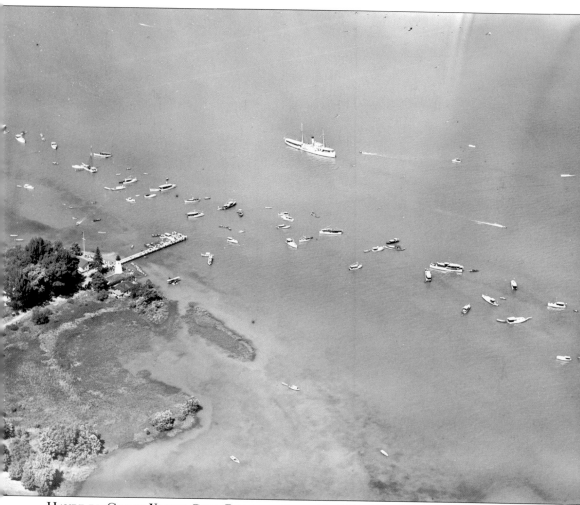

HAVRE DE GRACE YACHT CLUB REGATTA, JUNE 19, 1931. The Havre de Grace Yacht Club Regatta began 1930, was revived in 1999, and continues today as the Harford Hospice Regatta. In the aerial photograph, Lafayette Street is a dirt road and much of the area that has been filled in and made part of the Promenade was still only shallows. The regatta gained fame early on. In 1933, the publication *Motor Boating* said, "The success of the Havre de Grace Regatta this year earned it a place on the racing horizon. With eight new one mile world records established in the runabout, 125 inch hydroplane and outboard classes, this regatta held under the auspices of the Havre de Grace Yacht Club will go down into history as one of the most successful of the year." (Courtesy Hagley Museum and Library.)

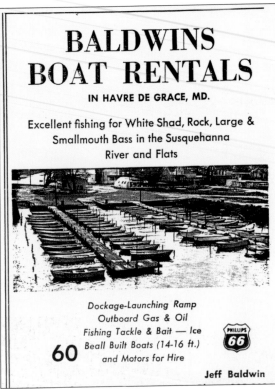

BALDWINS BOAT RENTALS

IN HAVRE DE GRACE, MD.

Excellent fishing for White Shad, Rock, Large &
Smallmouth Bass in the Susquehanna
River and Flats

Dockage-Launching Ramp
Outboard Gas & Oil
Fishing Tackle & Bait — Ice
60 Beall Built Boats (14-16 ft.)
and Motors for Hire

PHILLIPS 66

Jeff Baldwin

ADVERTISEMENT, BALDWIN BOAT RENTALS. Down at the other end of town on Water Street, several generations of Baldwins—Ed, Thomas, and Jeff—rented boats and gear. During Hurricane Agnes, the business took a major hit, as did most of the area. It later became transformed into Jean Roberts Park. (Courtesy the Historical Society of Harford County, Inc.)

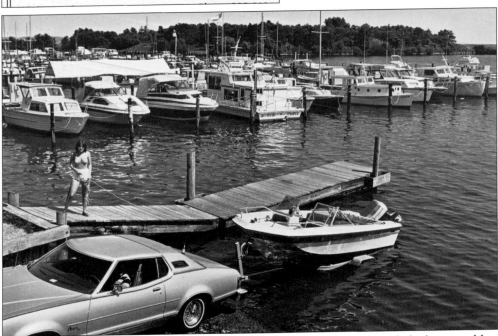

HAVRE DE GRACE YACHT BASIN. The yacht basin has always been a berth for boats and has played host to boats and pleasure craft from the fabulously wealthy and powerful to the rest of us. Especially during the late 19th and early 20th centuries, presidents and tycoons visited for the hunting. (Courtesy James Wollon.)

Three

LIFE ON THE WATER II

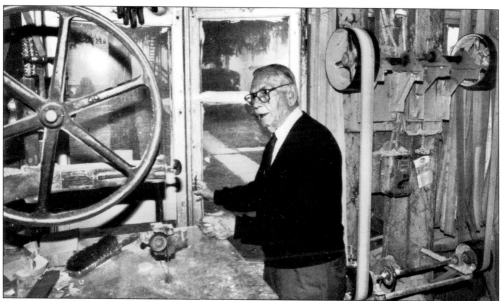

R. MADISON MITCHELL SR. R(obert) Madison Mitchell (1901–1993) lived through a time of transition for those in Havre de Grace who made their living on the water. The 1927 opening of the Conowingo Dam changed the area for better and worse. Not unlike the Nile River in ancient Egypt, whose annual floods destroyed and enriched the land, the Susquehanna cursed Havre de Grace with fierce floods and ice gorges that covered much of the streets close to the water. At the same time, the river blessed the residents with spawning grounds for fish and nutrients for plants that attracted and sheltered the waterfowl. The dam ended the cycle of flood and renewal. It also brought to a close the way of life for most of the fishers and hunters. Mitchell, the most revered decoy maker of his era, watched as decoys went from being tools to collectibles. He was intimately part of the planning of the Decoy Museum. In this photograph, he prepares his workshop to be dismantled and reassembled on museum grounds. (Courtesy Ellsworth and Madelyn Shank.)

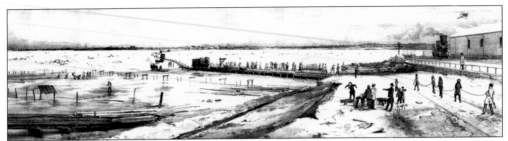

ETCHING, 1853: HAULING TRAINS ACROSS THE ICE. Before the railroad bridges were built, the Susquehanna was crossed by ferry. Even trains were carried across by boat to continue on track. But in 1853, the river froze so completely for a space of six weeks that no boat could cross. Tracks were laid directly on the ice from January 15 to February 29. The trains were hauled across. (Courtesy the Historical Society of Harford County, Inc.)

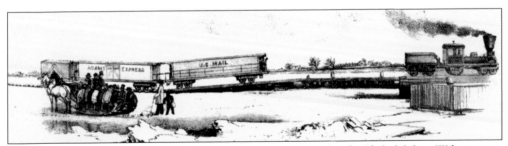

ETCHING, 1853: CHILLY MAIL FROM PERRYVILLE. For six weeks, the Philadelphia, Wilmington, and Baltimore (PWB) Railroad Company hauled across the ice over 1,378 cars with mails, baggage, and various kinds of merchandise. These cars were nearly all eight-wheel cars, which passed over without the slightest injury to any person or property. The amount of tonnage crossed was about 10,000, of which 4,000 was merchandise. (Courtesy the Historical Society of Harford County, Inc.)

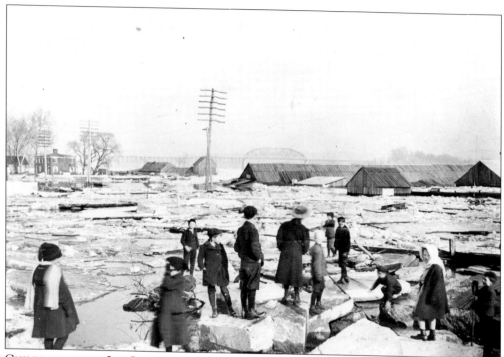

CHILDREN AT THE ICE GORGE. Here at the Canal Basin, children climb onto boulders of ice to see how the fish sheds that were stored for the winter have been engulfed by the icy waters of the river. The 1906 PWB Railroad Bridge stands in the distance past the lock house to the left of the photograph. (Courtesy the Historical Society of Harford County, Inc.)

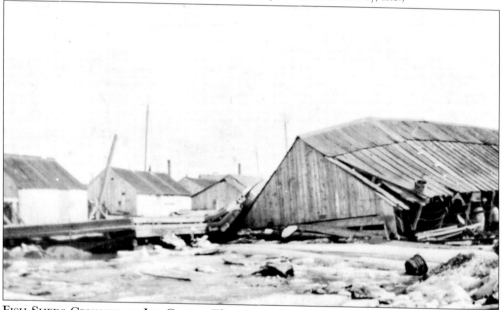

FISH SHEDS CRUSHED BY ICE GORGE. The annual freezing of the river was important to the local economy. The 1878 Harford Directory reports that "in favorable seasons . . . as much as 200,000 tons [of ice] has been cut in one season." (Courtesy the Historical Society of Harford County, Inc.)

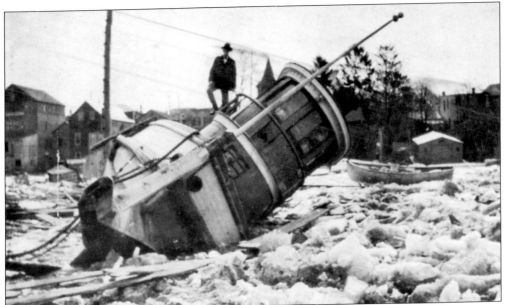

TUGBOAT TRAPPED ON THE ICE. Ice gorges occurred on the Susquehanna in 1904, 1907, and 1910. Here the tugboat *Champline* lies immobilized by the ice. Lloyd Shue recalls that his grandfather died when ice crushed the fish shed he was working on. (Courtesy the Historical Society of Harford County, Inc.)

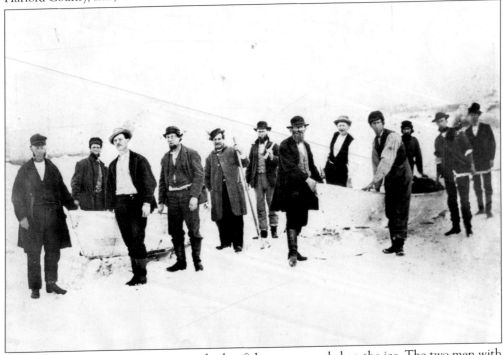

MEN ON ICE. This brave dozen rescued other fishermen stranded on the ice. The two men with poles (center) walked in front of the boats, tapping the ice for thin or broken spots. The other men dragged the boats, always holding on in case the ice broke. (Courtesy the Historical Society of Harford County, Inc.)

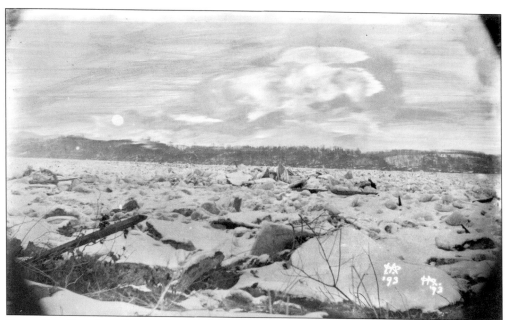

GOOD ICE, BAD ICE. Dennis Caudill recalls an old man who had seen ice cut. He said that the ice was sawed into huge blocks, hauled out, stored in straw on hillsides, and carted off for storage. They used ice tongs and pick axes to push and pull on the submerged blocks while horses, wearing ice shoes with saw blades attached, tugged on ice until it popped up far enough to pull over and out. (Courtesy the Historical Society of Harford County, Inc.)

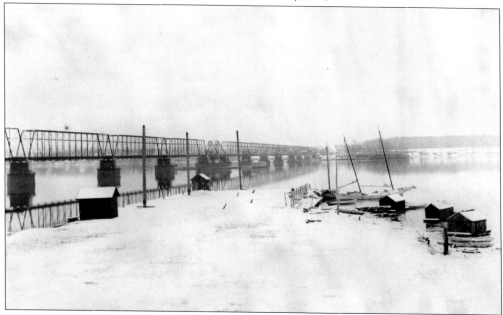

A CALM FREEZE. Most years, the river froze without violent gorges. Carrie Lawrence once skated, against her mom's orders, across the ice to Perryville when she was 9 or 10 years old. The ice creaked and swelled under her, and she thought it best to return by the bridge. Besides, she says now, Front Street was boring, with only a few shops. (Courtesy the Historical Society of Harford County, Inc.)

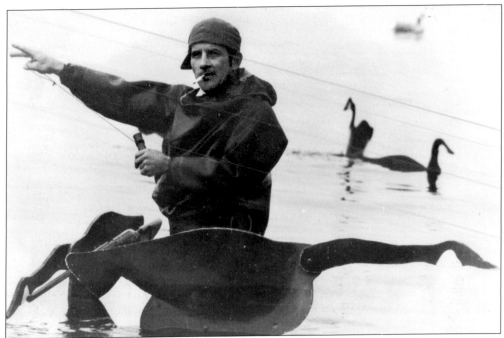

BODY BOOTING. This photograph of Robert "Jake" Wilson is from 1967. He is body booting on the flats. He is standing on one of two "stick ups" in the picture. These are four-foot-high metal stands in seven feet of water. The market gunning technique—a method of shooting ducks for market sale—was made illegal for safety reasons. (Courtesy Glenn Higgins.)

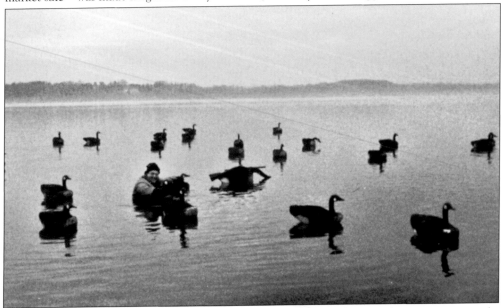

DUCK HUNTING. Duck hunting was a meat-gathering poultry industry as large in its own right as the fishing industry in Havre de Grace. The supply seemed limitless, the bagging relatively easy, and the payoff good. Over the years, hunting methods included shore blinds, field pits, ice blinds, and sinkbox gunning. Punt guns, taller than a man and held lying down in a skiff, killed dozens of ducks with one shot. The gauge was limited in 1918. (Courtesy Glenn Higgins.)

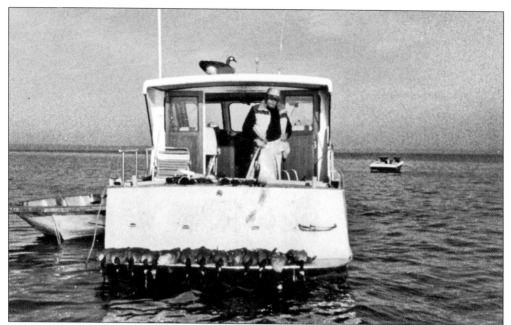

HAULING IN THE DAY'S CATCH. Here is a good day's catch on the *Wild Goose*, Glenn Higgins's boat. With increasing restrictions on hunting by the state and federal governments, Higgins decided to quit in 1984 and now runs a barber shop on Green Street. But in his heyday, Higgins said, other hunters would come in from the day and ask, "What did the *Wild Goose* kill?" The answer was: "Always more than everybody." (Courtesy Glenn Higgins.)

SCULPTING THE SHORELINE. Much of the waterfront area has been reinforced to accommodate buildings and the Promenade. For example, the shallows around the Decoy Museum site needed to be filled in before construction could begin. According to Margaret Jones, the army came to the rescue, filling the shallows with spare and broken vehicle parts, including damaged helicopters and jeeps. The museum itself is built around what used to be the steam heat plant and swimming pool for the Hotel Bayou. (Courtesy James Wollon.)

27

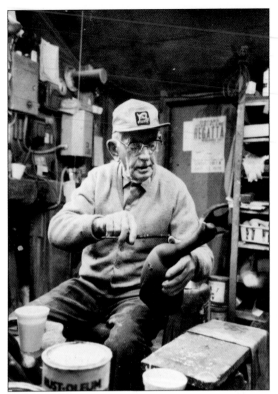

THE MASTER CARVER. R. Madison Mitchell is wearing the red sweater he loved to wear when working in his workshop. When he died in 1993, he was laid out for one night in the Decoy Museum. His daughter, Madelyn, asked that he be dressed in his red sweater and bow tie for that viewing. (Courtesy Ellsworth and Madelyn Shank.)

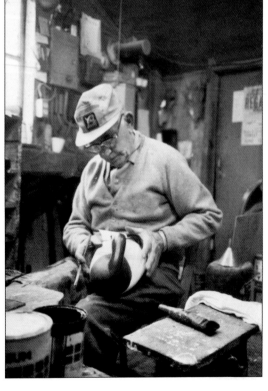

HIS DAY JOB. Mitchell was a funeral director by trade. When he was laid out in his own funeral home, Madelyn thought a suit and necktie more appropriate. This sequence of four photographs of her father hard at work on a decoy is Madelyn's favorite. (Courtesy Ellsworth and Madelyn Shank.)

THE TEACHER. Decoy makers and students came from everywhere to learn at Mitchell's workshop. But others came too. Mitchell's son, R. Madison "Mitch" Mitchell Jr., recalls a man, an Emmett Kelly type, who would bring the elder Mitchell fresh ducks that died after flying through windows. The man died in 1953 on the steps of Goll's Bakery. (Courtesy Ellsworth and Madelyn Shank.)

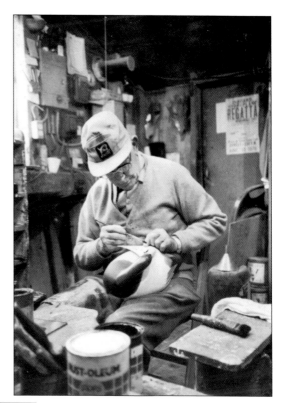

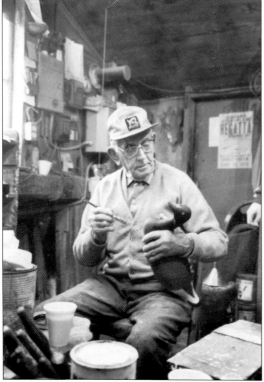

A BRIDGE TOO FAR. Another story from Mitch Mitchell is about a trip his dad made to a nursing home off Route 1 to pick up a body. As a tired Mitchell came across the Forge Hill Road bridge, the black hearse he was driving clipped the corner of the concrete bridge. For the longest time, the black mark was still there. (Courtesy Ellsworth and Madelyn Shank.)

ADVERTISEMENT, SENECA CANNERY. Just as Mitchell and others created decoys and so gave hunters the tools needed for their work, processors and packers such as Seneca, not content with the income from producing and packing their own goods, sold the equipment and supplies that other producers and processors needed, thus diversifying and expanding their line. Forty-five Havre de Grace farmers are listed in the 1878 directory, making a profitable base for Seneca. (Courtesy Pat Mergler, Seneca Cannery Antiques.)

Four

RAILROADS
AND ROADWAYS

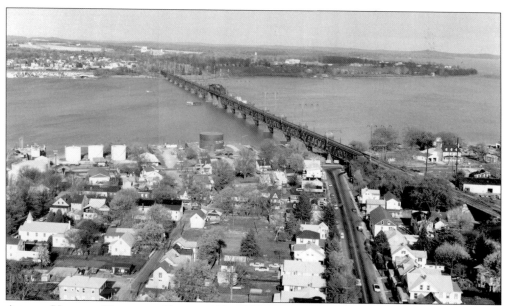

AERIAL VIEW OF HAVRE DE GRACE, 1978. If fishing, farming, and hunting had anything in common, it was the need to move the product to market. The canal and ship gave way to the train and the truck once tracks and decent roads were laid. The Old Post Road was replaced by the new Route 40 in 1940. Access to the new Interstate 95 in 1963 put Havre de Grace back in the middle of the East Coast in terms of ease of travel. Havre de Grace always had the good fortune to be located on two major train routes, which still run today. In this photograph of the Amtrak Northeast Railroad Corridor, the Juniata Street Culvert is the focus. Some familiar landmarks are noticeable near the water line: to the right of the bridge, the Lafayette Hotel, now the American Legion building; and to the left of the bridge, the tanks of Gilbert Oil. (Courtesy Library of Congress.)

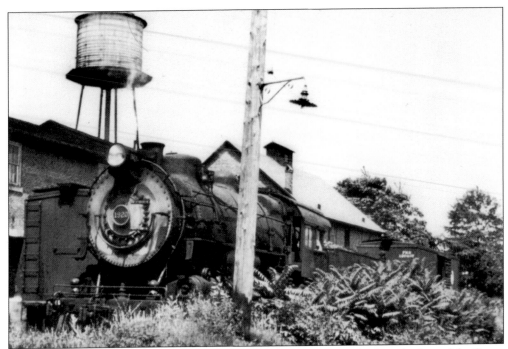

LOCOMOTIVE AT SENECA CANNERY WAREHOUSE. The cannery was built at the foot of the Cut, a spur built from the main track, entrenched down Pennington Avenue (called St. Clair Street back then) and then to the dock. Originally the Cut was where the train would get the ferry across the Susquehanna before the bridge was built. (Courtesy Pat Mergler, Seneca Cannery Antiques.)

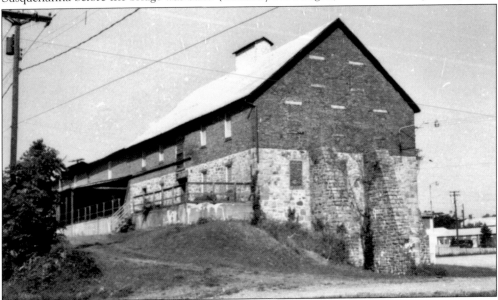

SENECA CANNERY. The Seneca Cannery processed locally grown tomatoes. Steam was used to cook the tomatoes; the cans were sealed and crated for shipment on the train. Many canneries throughout Harford County were built of wood and have burned down or been otherwise destroyed, but a few well-built ones remain, including the brick and stone Seneca Cannery. Mitch Mitchell remembers the yummy smell of tomatoes thick in the air. (Courtesy James Wollon.)

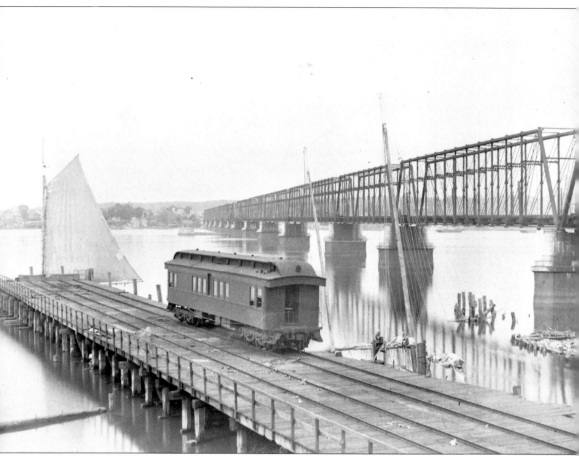

PWB BRIDGE. In 1838, three railroad systems merged: the Philadelphia, Wilmington, and Baltimore Railroad of Pennsylvania (PWB); the Wilmington and Susquehanna Railroad of Delaware; and the Baltimore and Port Deposit Railroad of Maryland. By 1866, this fine iron bridge spanned the Susquehanna between Havre de Grace and Perryville. The awkward process of ferrying trains across the river came to an end. In this c. 1890 photograph of the foot of Warren Street is the PWB Bridge. Alongside it is the ferry launch that is no longer needed. Another ferry—where the ice tracks were built in 1853—was down at St. Clair Street (now Pennington Avenue). The Pennsylvania system absorbed the Philadelphia, Wilmington, and Baltimore Railroad in 1902, and in 1906, the new Pennsylvania Railroad bridge was completed. The original bridge was then used for vehicular traffic. In the 1920s, it was made into the only double-deck vehicular bridge in the country. It was closed in 1940 when the new Route 40 bridge over the lower end of Garrett Island was finished. (Courtesy the Historical Society of Harford County, Inc.)

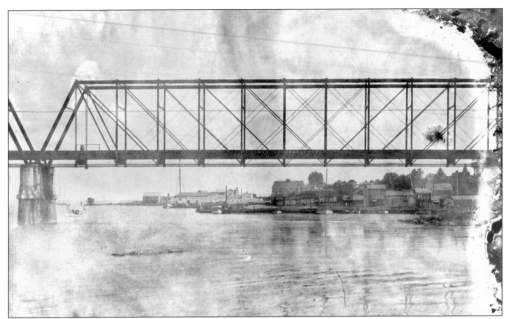

LONG DISTANCE. The days of the early railroad were also the days of the telegraph, whose poles carried the singing metal wires insulated by glass. A rate card for the Magnetic Telegraph Company explains that every 10 words, exclusive of address and direction, between Havre de Grace and Baltimore was 10¢, between Havre de Grace and New York was 45¢. (Courtesy the Historical Society of Harford County, Inc.)

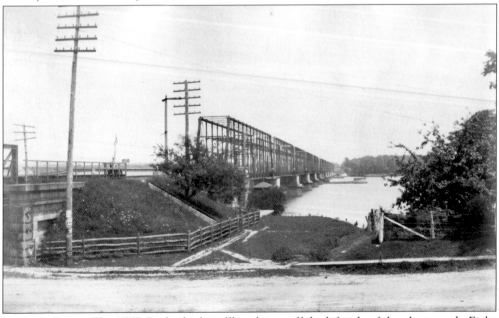

MONEY MAKER. The PWB Bridge had a tollbooth just off the left side of the photograph. Eight local men bought this bridge in 1910, when the Pennsylvania Railroad built a new bridge. They made $1 million by charging tolls for vehicles, and then sold it to the state in 1923. To ease the flow of two-way traffic on a 13-foot-wide bridge, the state added a second level. (Courtesy the Historical Society of Harford County, Inc.)

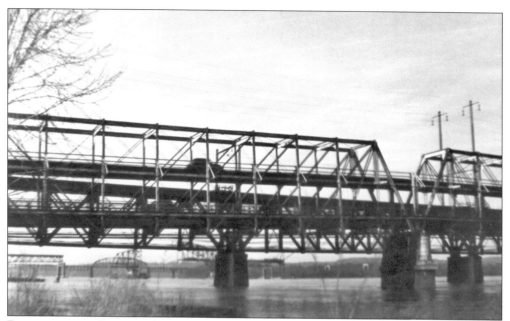

DOUBLE-DECKER BRIDGE. The new problem for the PWB Bridge was that trucks stacked too high with freight became wedged between the deck and the overhead structure and could proceed only after their tires were deflated to allow adequate clearance. The continued difficulties with the bridge eventually led to the creation of the Route 40 bridge in 1940. (Courtesy the Historical Society of Harford County, Inc.)

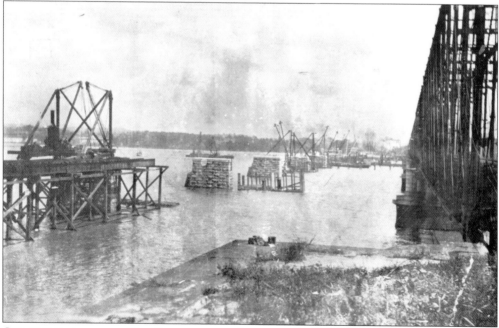

CONSTRUCTION OF THE NEW PENNSYLVANIA RAILROAD BRIDGE. The bridge seems to be creating itself in this amazing photograph. The old railroad bridge is to the right, but it was dismantled in 1943, shortly after the new Route 40 bridge opened. The official story says that the metal was used to help the war effort. Others are not so sure. (Courtesy Richard Tome.)

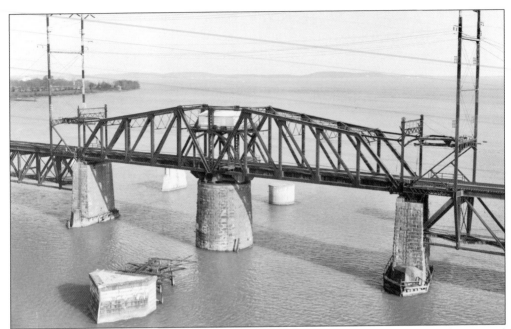

PENNSYLVANIA RAILROAD BRIDGE, 1978. In this photograph, only the pilings of the original bridge remain. The photograph conveys the massiveness of the bridge and the power of its pilings. The angled middle structure in the water in front of the span and the angled piers on either side are for protection from ice or debris, similar to a cow-catcher on a train. (Courtesy Library of Congress.)

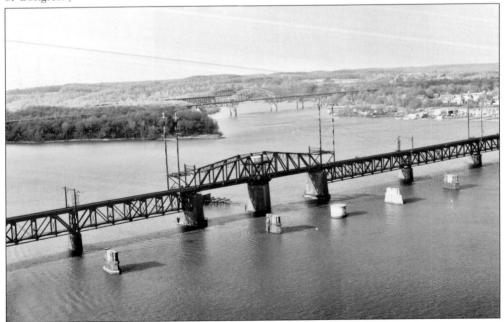

A VIEW OF BRIDGES, 1978. In this view of the same bridge from its eastern side, the pilings of the old bridge are quite clear. To the right is the Perryville shore; to the left is Garrett Island, in the middle of the Susquehanna. The other bridge in the distance uses Garrett Island as a base for many of its support piers. (Courtesy Library of Congress.)

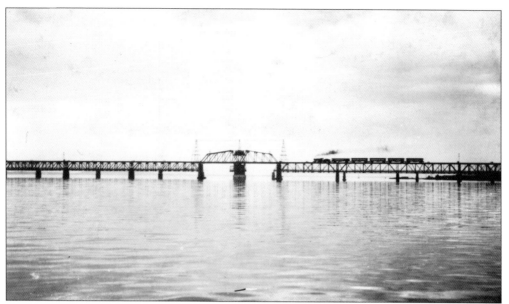

A ROMANTIC VIEW. While this is a photograph of the same bridge as in the previous photographs, the era is far earlier, going back to the days of the steam locomotive. (Courtesy the Historical Society of Harford County, Inc.)

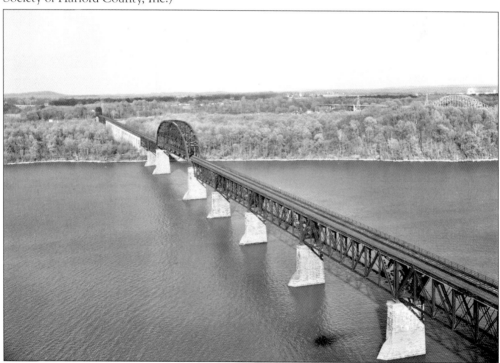

PERRYVILLE RAILROAD BRIDGE, 1978. Now a CSX bridge, the original single-track bridge built by the Baltimore and Philadelphia Railroad was forced to detour trains over the Pennsylvania Railroad between 1908 and 1910 due to a freight derailment and span collapse as it was being rebuilt to double-track. The Baltimore and Ohio (B&O) double-tracked it and returned it to service. The second track has since been removed. (Courtesy Library of Congress.)

B&O BRIDGE OVER SUPERIOR STREET. In this *c.* 1890 photograph, the B&O train comes into Havre de Grace over Superior Street, as it still does today. The bridge crossing Garrett Island in the Susquehanna was named after John W. Garrett, former president of the B&O. (Courtesy the Historical Society of Harford County, Inc.)

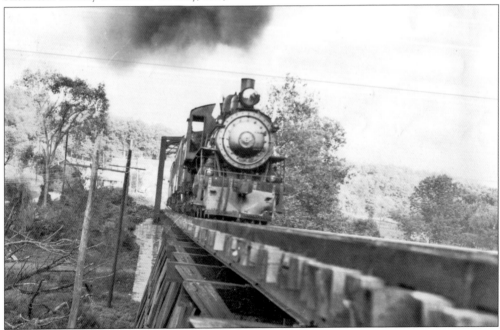

THUNDERING OVER SUPERIOR STREET. This dynamic photograph shows a steam locomotive crossing the bridge over Superior Street. The photograph conveys the sense of thundering excitement passersby on the road must have felt as the train went over the span. (Courtesy the Historical Society of Harford County, Inc.)

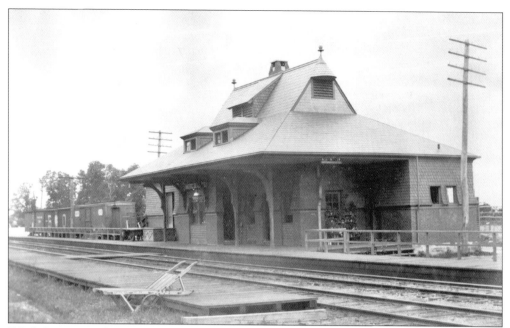

B&O STATION. The telegraph lines come into the station just at the right-hand side of the roof overhang. A cart of potted plants sits below it against a window. This photograph and the next (as well as others in this book) are from an album of photographs taken around 1884 to 1894 that belonged to Dr. Alexander Stewart Koser of Havre de Grace. (Courtesy the Historical Society of Harford County, Inc.)

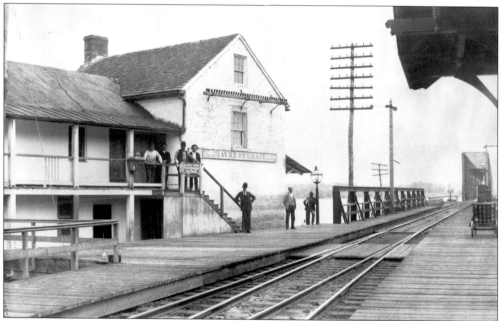

PWB/PENNSYLVANIA STATION. The original station is directly down from the bridge, visible in the photograph. The original B&O station burned. Both it and Penn Station were rebuilt near Adams and Franklin Streets, near Tawney's Garage across from Carroll Laundry. (Courtesy the Historical Society of Harford County, Inc.)

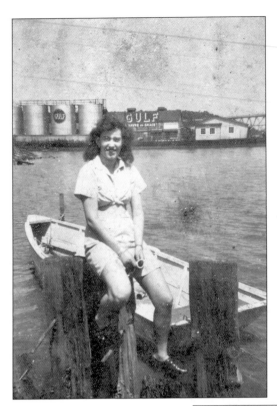

GILBERT OIL. Behind Florence Brennan, who is sitting on a pier, are the tanks that belong to Gilbert's Gulf Oil across from Price's Seafood on Water Street. Oil barges carry oil in to fill the tanks. The space around the tanks was broader than it appears here, and folks often went fishing in front of the tanks on the wharf; kids would also jump off to swim in the river. (Courtesy Brenda Baker.)

JAMES BRENNAN. Florence Brennan is Brenda Baker's mom. James is her dad. They lived at 715 Stokes Street, where Brenda was raised. James was a paper hanger. After serving in World War II, he worked as a civilian employee at Bainbridge Naval Station and Edgewood Arsenal. (Courtesy Brenda Baker.)

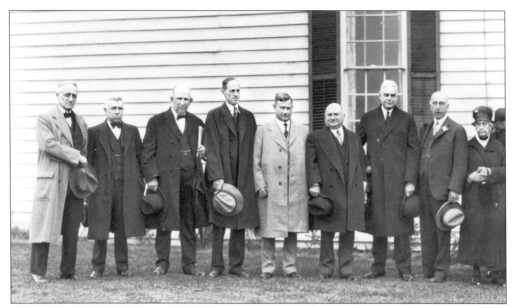

MILLARD TYDINGS AND A GROUP OF MEN. A young Millard Tydings stands fourth from left in this group photograph. The Interstate 95 bridge was named in his honor. From his army service in World War I to his service as a U.S. senator from Maryland, the Havre de Grace native was a man of honor and a hero. (Courtesy the Historical Society of Harford County, Inc.)

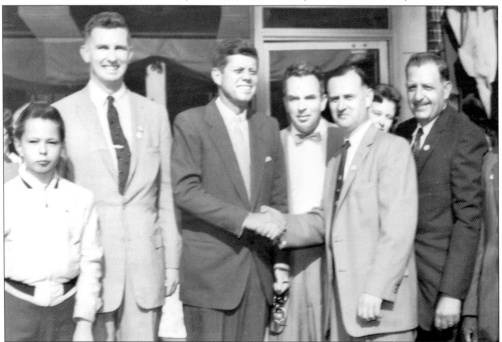

JOSEPH TYDINGS AND PRESIDENT KENNEDY. Sen. Joseph D. Tydings was the adopted son of Millard Tydings. He followed in his father's political footsteps. Like his father, he often championed controversial issues and had detractors from both sides of the political spectrum. In this photograph, a young Tydings stands to the left of the president. Mayor Thomas D'Alessandro of Baltimore is on the far right. (Courtesy the Historical Society of Harford County, Inc.)

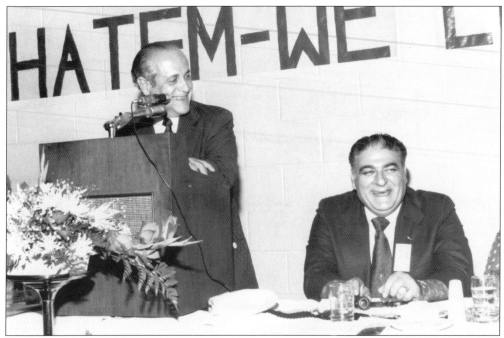

THOMAS HATEM AND GOV. MARVIN MANDEL. The Route 40 bridge is named for Thomas J. Hatem, a distinguished citizen of Harford County, who devoted his life to public and civic service. In this photograph, Hatem enjoys a remark by Maryland governor Marvin Mandel. (Courtesy the Historical Society of Harford County, Inc.)

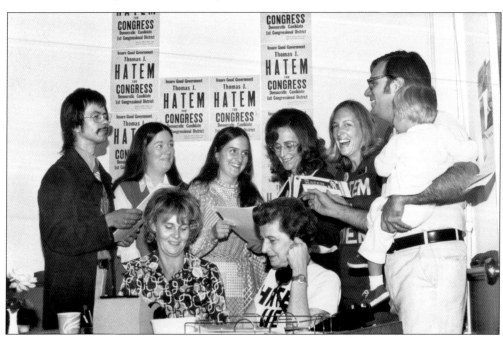

HATEM SUPPORTERS. Using the slogan, "Hatem—We Love Him," these loyal Hatem fans work the telephones and coordinate plans to get Hatem elected for First Congressional District representative. (Courtesy the Historical Society of Harford County, Inc.)

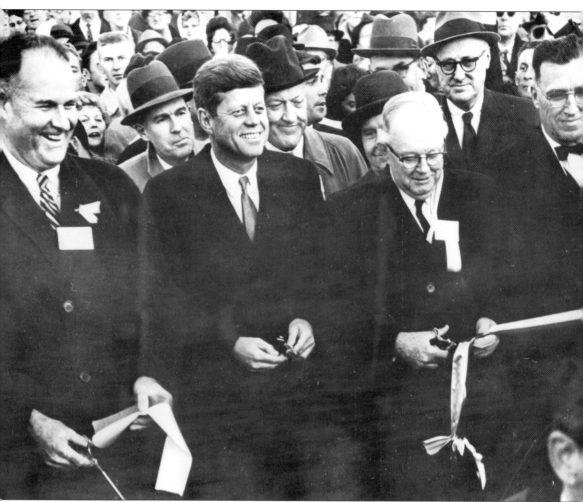

PRESIDENT KENNEDY OPENS INTERSTATE 95. The toll bridge is named for Millard Tydings (1890–1961), U.S. senator from 1927 to 1951. The highway and bridge were dedicated by Pres. John F. Kennedy on Thursday, November 14, 1963, only eight days before he was assassinated in Dallas, Texas. The highway was renamed for Kennedy in 1964. To Kennedy's right is Maryland governor Millard Tawes. Behind the president to the left is Sen. William James of Havre de Grace. Tydings's great-great-great grandfather was John O'Neill, the hero at the burning of Havre de Grace in 1813. Tydings led a "suicide squad" battalion of machine gunners in World War I and alone captured three Germans while behind enemy lines, armed with only a pistol. As a senator, he faced the wrath of Pres. Franklin D. Roosevelt over packing the Supreme Court. He was also targeted by Sen. Joseph McCarthy. He authored legislation to create the University of Maryland, to give independence to the Philippines, and to require a balanced federal budget. (Courtesy Walter S. Johnson.)

ROADSIDE AMERICA. In its heyday as America's highway, Route 40 was a ribbon of motels, diners, ice-cream stands, and giant muffler men. The opening of Interstate 95 pulled a lot of traffic away from Route 40. This 1960s-era photograph shows the Bayou Restaurant, still one of Harford's finest places to dine. (Courtesy James Wollon.)

SIX THOUSAND TROOPS MARCHED HERE. During the American Revolution, many of the Continental troops went across the Susquehanna by the Havre de Grace ferry. On his way to Rhode Island, Jean Baptiste, Count de Rochambeau, led 6,000 French soldiers and camped along the Old Post Road in the area of the old race track and the present Maryland National Guard facility. The Route 7 turnoff pictured here leads to that area. (Courtesy James Wollon.)

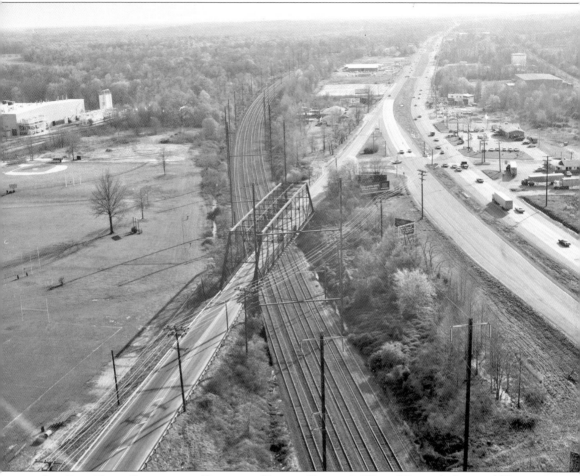

OLD POST ROAD BRIDGE OVER RAILROAD TRACKS, ROUTE 7. West of Havre de Grace, old Route 40 (now Route 7) merges with Pulaski Highway (modern Route 40). Just before the merge, old Route 40 crosses the main rail line on an old iron truss bridge, which is today a concrete bridge. Havre de Grace was from its beginning admirably situated for water and land transportation. Stage coaches operated regularly on the Old Post Road. For the almost 400 years since John Smith first sailed up the Chesapeake Bay, ferries, bridges, railroads, and highways aided the flow of people, goods, and of course, money. The town was host to the first great American heroes and patriots, and it gave rise to its own heroes and people of vision and service like John O'Neill, Millard Tydings, William James, Thomas Hatem, and Madison Mitchell. And always, people came to settle in Havre de Grace, to live and work here: the English, the slaves, the Irish, the Italians, and others through the years. (Courtesy Library of Congress.)

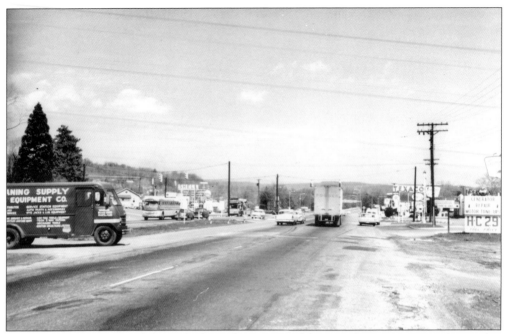

FILL 'ER UP! This 1950s photograph shows the primacy of the auto along Route 40 in the number of gas stations available in such a short stretch. From left to right there are Shell, Texaco, Esso, and Sinclair stations. The truck in the foreground delivers service-station equipment and auto parts. A car carrier is a little farther down the road. (Courtesy James Wollon.)

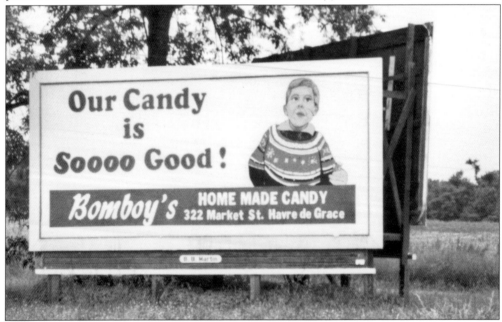

BILLBOARD FOR BOMBOY'S CANDY, 1982. The golden age of the automobile introduced the golden age of the billboard—the perfect advertising medium in the era of the open road. Although Bomboy's opened in 1978, long after Route 40 had seen its glory days, the Bomboy's billboard has been a mainstay of the road leading into town. (Courtesy Charlie Bomboy.)

Five

WORK AND LIFE

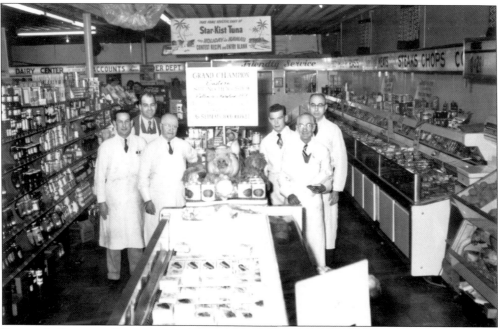

SEIBERT'S GROCERY. For many people in past generations, to work was to live. In Harford County today, there are still a few business owners and employees who have no thought of retirement. They will open up, do the job, and keep at it every day until they die. Take Herman C. Seibert. He was part owner of several general stores in the Perryman area. Eventually Herman opened his own grocery store in Havre de Grace in 1941 at 114 North Washington Street and moved the business to 137 North Washington Street around 1952. Herman and his son, Charles, also had a restaurant downtown. One day Herman, who was also a butcher in the store and who had diabetes, dropped a ham on his toe. Gangrene set in, he lost both legs, and died at age 60. Yet he went into the store every day he could during his illness. Pictured from left to right are Phil Jones, Charles Seibert, Gold(ie) ?, James Hadwin, unidentified, and Herman Seibert. (Courtesy David Seibert.)

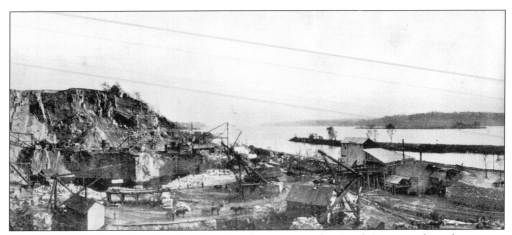

PORT DEPOSIT QUARRY. Just north of Havre de Grace on the Cecil County side is the quarry. This photograph and the next are taken from a panoramic photograph and belong side by side. In this early-20th-century photograph, mules pull carts full of stone to buildings for crushing or to railway tracks for transport. The work has always been hard and dangerous. (Courtesy Richard Tome.)

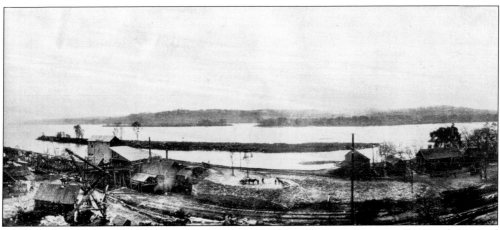

LOCAL SOURCE OF GRANITE. Just as many roofs in Harford County are covered by North Harford and Delta slate, so are many buildings made of Port Deposit granite, quarried here. (Courtesy Richard Tome.)

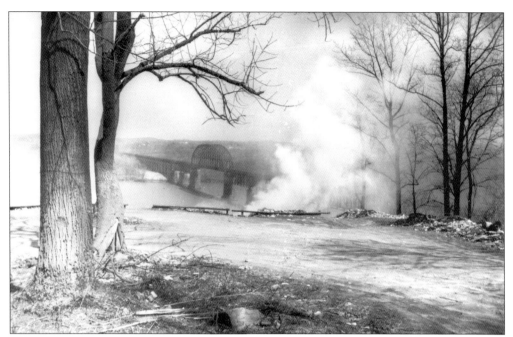

A MISTY VIEW. The landfill was up Superior Street (Route 155), past the quarry road, and across from the Catholic cemetery. But that has only been one of the town's dumps over the years. Today the area is part of the grounds of the Havre de Grace Community Center off Lagaret Lane. The Perryville Train Bridge is in the hazy distance. (Courtesy James Wollon.)

SHOOTING GALLERY. According to Mitch Mitchell, the police used the dump area for shooting practice; so did local youths, aiming at cans, trash cans (note the bullet-riddled receptacle in the foreground), and rats. The awful-smelling smoke from the smoldering trash was ever present. (Courtesy James Wollon.)

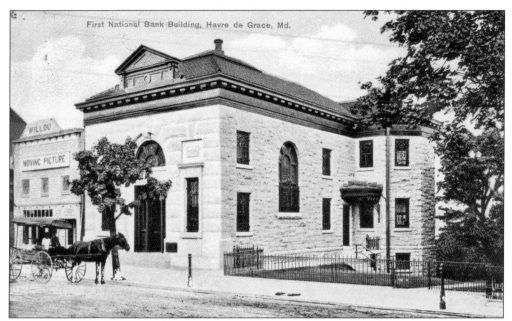

FIRST NATIONAL BANK BUILDING. This image is from a postcard dating from around 1900, and reveals the beauty of the bank building. The square front section projects solidity and security—good qualities for a bank. But the back expands in a gently angled pair of joined towers. The overhang of the covered side entrance seems to float. And don't miss the Willou Movie Theater next door. (Courtesy the Historical Society of Harford County, Inc.)

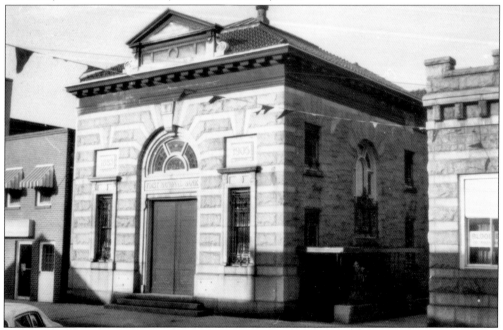

FIRST NATIONAL BANK BUILDING. To the right of the bank on St. John Street is a second building in a similar style. Unfortunately the new building is built so close to the bank, it hides the more spacious area in back. In this photograph, the new building was a blood bank. Today the bank is an antique shop with the appropriate name of Bank of Memories. (Courtesy James Wollon.)

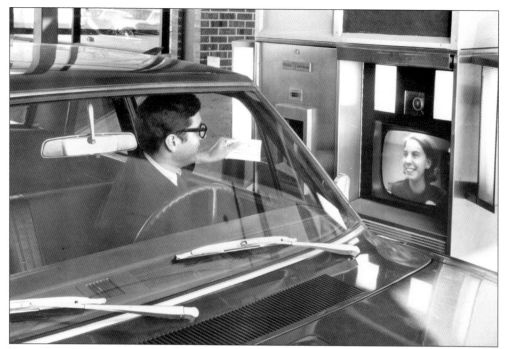

First Automated Teller. Every technology is new sometime. This represents the first video drive-in at a bank in town—Equitable Trust Bank. The customer's envelope has an ad for Painter's Mill Music Fair on it. (Courtesy the Historical Society of Harford County, Inc.)

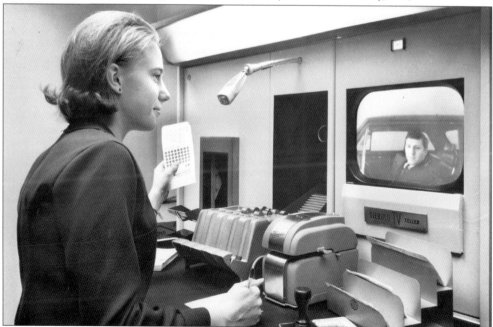

First Automated Teller. There's a continuity problem: wasn't the customer wearing glasses? The video camera from Diebold Teller sees all. Of course, before long banks realized that customers didn't really need to see the teller, and ATMs replaced live bodies for 24-hour service. But they still watch us, for security, of course. (Courtesy the Historical Society of Harford County, Inc.)

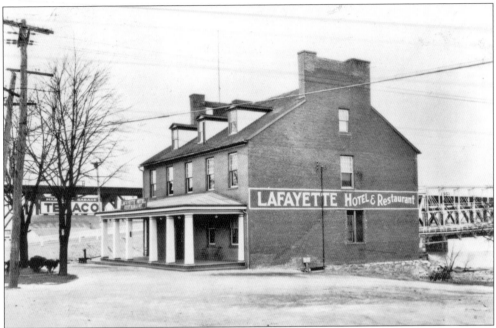

LAFAYETTE HOTEL. This photograph of the Lafayette Hotel has the double-decker bridge in the background as well as the new Pennsylvania Railroad Bridge. It was probably taken not long after the second level of the bridge was added. The hotel became the American Legion hall in 1948 thanks to members of the Legion. (Courtesy Glenn Higgins.)

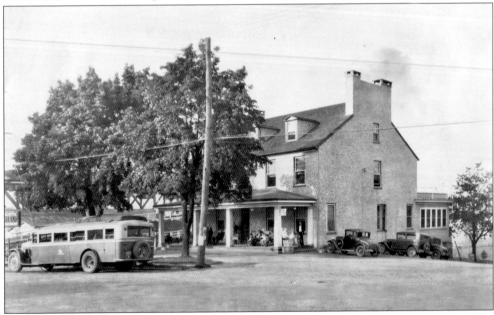

LAFAYETTE HOTEL AND BUS. This is a slightly later photograph from the previous one. The back addition has been put on. The building began as the Jarrett house, a private residence. It became the Lafayette Hotel, trading on the town's history and the hotel's location on old Route 40 right next to the entrance to the double-decker bridge. (Courtesy the Historical Society of Harford County, Inc.)

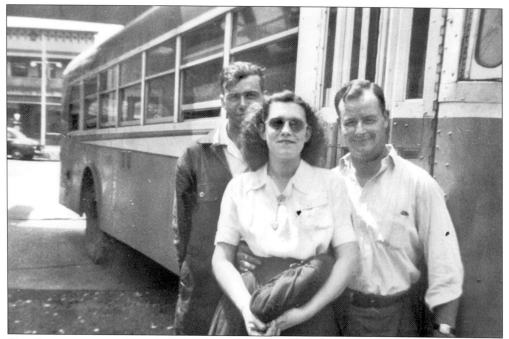

THE BRENNANS WITH BUS. This bus carried passengers between towns in the county and down to Baltimore. For those without cars, especially in the early decades of the 20th century when automobiles were new and often scarce, especially for the less well off, the bus was the main way of getting out of town. (Courtesy Brenda Baker.)

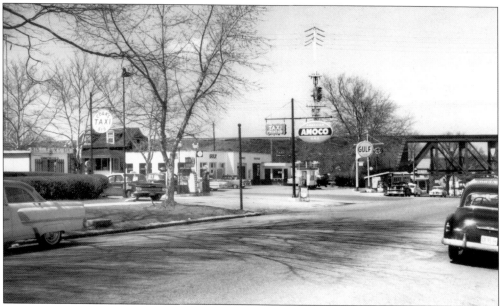

GAS AND TAXI STATIONS. Across the street from the Lafayette Hotel and the entrance to the double-decker bridge was this area, now known as Union Square. Note the three-digit phone numbers typical of 1950s Havre de Grace. Montville Taxi (still in business today) is nestled with the Gulf station, while Coen's Taxi is with the Amoco dealer. The tiny Bridge Diner is to the right of the Gulf sign. (Courtesy James Wollon.)

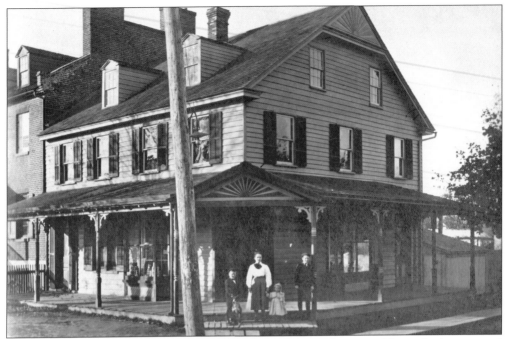

STORE ON SOUTHWEST CORNER OF ADAMS AND OTSEGO STREETS. Now split into several addresses, the home once had a corner entry typical of many corner stores. The unidentified owner and family stand outside the entrance. Cans are displayed in a bay window to the left. The striking sunburst above the door is echoed at the angle of the roof, which is the only distinctive architectural feature that remains today. (Courtesy the Historical Society of Harford County, Inc.)

A&P STORE AND LOT, MARKET STREET. The A&P Food Store was built on the site of the Market Street landfill, essentially on a platform supported by trash. Pilings were driven through the garbage to a secure footing. The idea worked, but the garbage attracted rats, and the store didn't want them inside, so they had two-inch pipes driven into the trash and gassed the rats with a poison. (Courtesy James Wollon.)

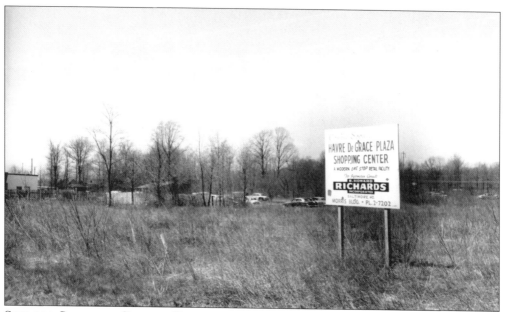

SITE FOR SHOPPING CENTER, REVOLUTION STREET. Promising a "modern one-stop retail facility," this sign announces the first planned shopping center in town. As happened in many smaller towns, the main street or downtown area wasn't large enough to allow food stores, the first of the major retailers to expand in size and grow, so they were often the first to move to the outskirts or undeveloped sections of town, giving rise to the strip shopping center. (Courtesy James Wollon.)

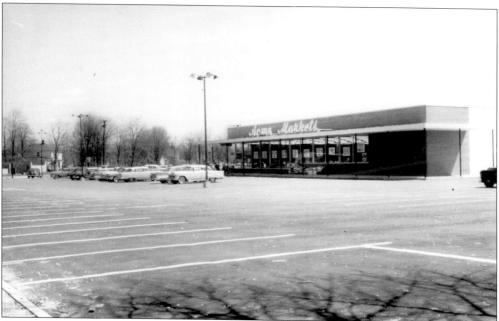

ACME STORE. And voila—here it is. It isn't really an entire shopping center, just a single Acme store. More stores would be added later. But check out the 1950s Chevys in the parking lot. While hard to read, the prices in the store window seem to be mostly under a dollar. Today this is the Parris-Castoro Eye Center. (Courtesy James Wollon.)

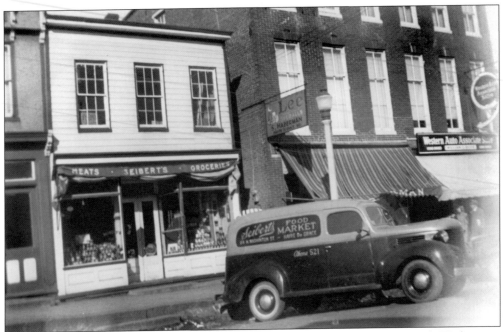

SEIBERT'S GROCERY. This was Herman Seibert's first Havre de Grace store, at 114 North Washington Street, bought in 1941. Notice the phone number—521. This was also back before the streets were repaved: note the raised, uneven curb. S. Haberman's store is next door, and the Western Auto is down from that. (Courtesy David Seibert.)

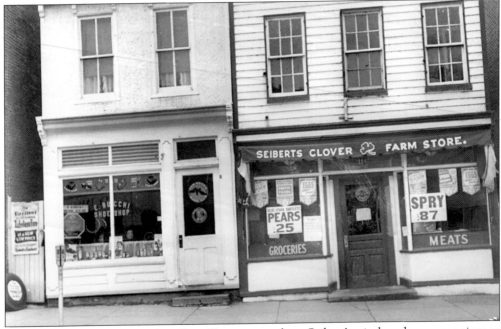

SEIBERT'S GROCERY. E. Bucchi's Shoe Shop is next door. Seibert's windows have some signage advertising Easter foods, such as ham and eggs. Spry was a brand of shortening. There were other small grocery stores in town: Pop Klair's, Maslin's at 113 South Washington, L&P Grocery Store, and later on, Tillie's on Juniata Street. (Courtesy David Seibert.)

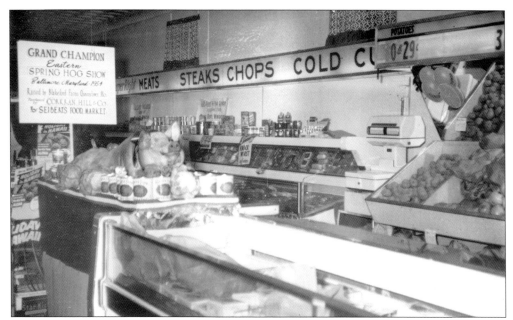

SEIBERT'S GROCERY, 1954. This interior photograph of Seibert's second grocery store at 137 North Washington Street, across the street from his first store, shows the proud display of the prepared grand champion from the Eastern Spring Hog Show. What set the various corner markets apart from each other was the quality of their foods, especially their meats, so the hog was a good choice to show off Seibert's butchery skills. (Courtesy David Seibert.)

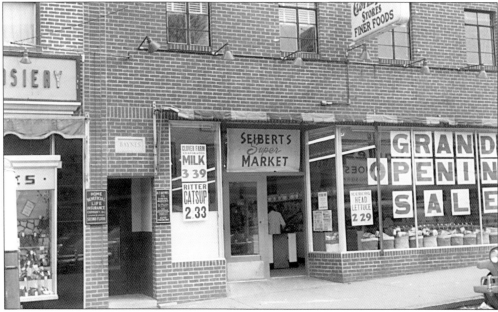

SEIBERT'S FOODLAND GROCERY, 1952. The corner store often did business in a more personal way than the coming supermarkets would. Being one of the neighbors made shop owners more tuned in to their neighbors' needs. Mitch Mitchell recalls how his dad would go into Maslin's—a fancy grocer and butcher—the day after Christmas and pay his bill for the entire year. Now that's credit. (Courtesy David Seibert.)

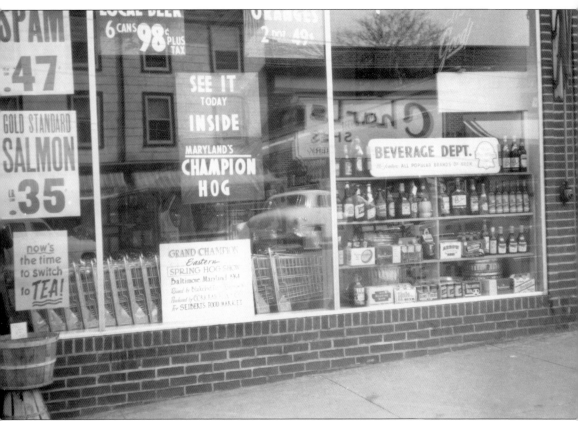

SEIBERT'S GROCERY. Some folks may remember Pop Klair's grocery store on Ontario Street (telephone 240), or more recently, Tillie's at Juniata and Erie Streets. As with many of the stores in town, the business was on the street level, and the owners lived above. Tillie's was owned by Nikki Languis's Aunt Tillie, who opened the store in the Juniata Street house Nikki grew up in. Ralph Lawrence and his wife's brother had the L&P Grocery Store (for Lawrence and Poplar) on Union Avenue that specialized in serving the military at Aberdeen Proving Grounds and Bainbridge Naval Institute. Ralph did not have to serve in World War II, since he was supporting the military and their families at home. Extending credit to families with dads, husbands, and sometimes wives and moms at war may have played a role in that deferment. Carrie Lawrence remembers the store's grand opening, when it gave away a whole ham, which was won by a local "colored" woman, as Carrie says. (Courtesy David Seibert.)

HERMAN SEIBERT, JUNE 1948. Wanting to do more for his town, store owner and butcher Herman Seibert took a stab at politics. He ran for mayor of Havre de Grace once and for a seat on the city council three times but never won. The *Harford Democrat* dated May 7, 1951, shows the mayoral candidates as Dr. Lyttleton Green, Walter McLhinney, J. C. Vanchiere, and Herman Seibert. (Courtesy David Seibert.)

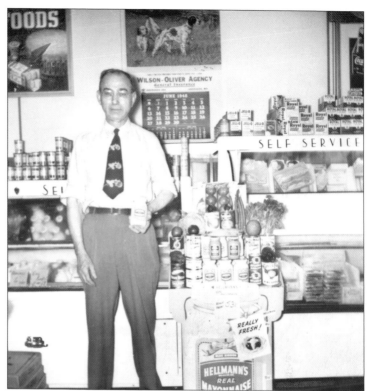

HOWARD DENNISON. Known as "Mr. Denny" to young David Seibert, Howard Dennison drove the delivery truck and worked for Herman Seibert, and later for his son Charles, every year that Seibert's Grocery was in business. In an era when individual relationships mattered more than the bottom line, employees often became like extended members of the employer's family. David Seibert recalls the holiday parties at their home, where employees always had a special place. (Courtesy David Seibert.)

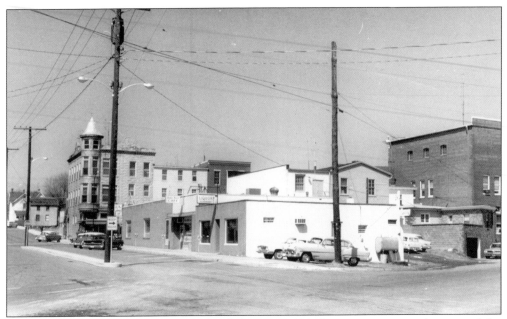

ROBIN HOOD CAFÉ. After the repeal of Prohibition in 1933, the county attempted to control the flow of hard liquor by using the dispensary system—the county-owned locations where whisky, bourbon, and other high-alcohol-content beverages could be bought for home consumption. Oddly enough, beer and wine were available on just about every street corner. And alcohol could be served at restaurants and bars all over town. (Courtesy James Wollon.)

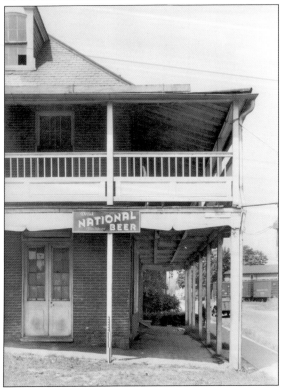

THE OLD ORDINARY. Ordinary was another name for a tavern. Built around 1820, the Old Ordinary, like other structures that have a long history in Havre de Grace, has served many purposes. In this 1930s photograph, the building, at St. John and Congress Streets, was a club frequented by African American adults. Note the billboard for National Beer that echoes the sign on the club's door. (Courtesy James Wollon.)

THE RODGERS HOUSE. Another of Havre de Grace's survivors is the Rodgers House, which stood through the 1813 burning of the town. George Washington had dinner there. The Rodgers family has a long history in town as well. Commo. John Rodgers served in the War of 1812; his son, John Rodgers, in the Civil War; and his great-grandson, John Rodgers, in World War I—all were navy men. (Courtesy James Wollon.)

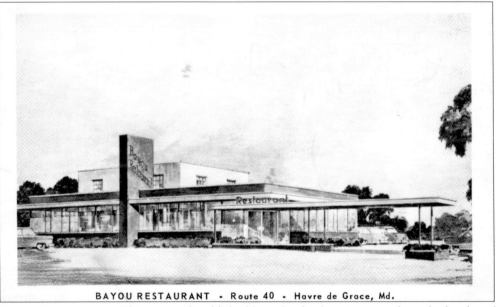

BAYOU RESTAURANT · Route 40 · Havre de Grace, Md.

BAYOU RESTAURANT. This postcard, published here for the first time, was from the heyday of Route 40 and the desire for motels, restaurants, and roadside attractions to give patrons a token of their visit and a gentle reminder to come again next time they were driving through. Happily the Bayou is still a fixture of the Harford County restaurant scene. (Courtesy James Wollon.)

HARDEE'S DEVELOPERS. After the old McDonald's opened on Route 40, others, such as Hardee's, scurried to imitate its drive-up appeal. Lloyd Shue recalls working the 10:30 p.m. to 4:00 a.m. shift at Gino's in Bel Air, another of the era's contenders in the burger wars of the late 1950s and early 1960s. Havre de Grace had Marchetti's, owned by the Baltimore Colt football great Gino Marchetti. (Courtesy the Historical Society of Harford County, Inc.)

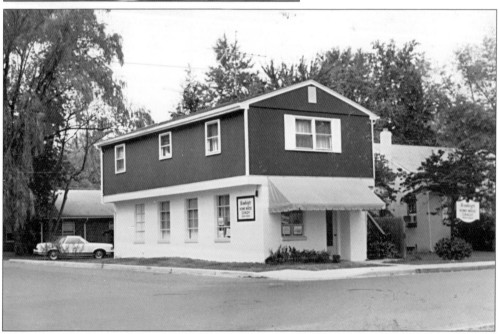

BOMBOY'S BUILDING. Since 1978, Bomboy's has been the premier candy maker in Havre de Grace. Their signature candy is named for the city—Havre de Mints, mint green and dark or milk chocolate discs. This is how their original home and shop at Market and Girard Streets appeared in 1978. (Courtesy Charlie Bomboy.)

CHARLIE AND KATHY BOMBOY, 1986. Over the years, the Bomboys more than doubled the size of their candy store but still needed room for their ever-expanding business. In 2000, they built their new store across the street, opening in November, in time for the Christmas rush. Charlie opened his homemade ice-cream store in the original building after taking the Penn State Ice Cream Course. Now folks come from all over for the best candy and ice cream in town. One of Charlie's favorite Havre de Grace memories involves candy (of course). At Christmastime, the State Theater would have a special holiday movie and cartoons, following which all the Havre de Grace firemen lined up on both sides of the aisle, Santa himself came on stage, and each child received a big orange and box of candy. (Courtesy Charlie Bomboy.)

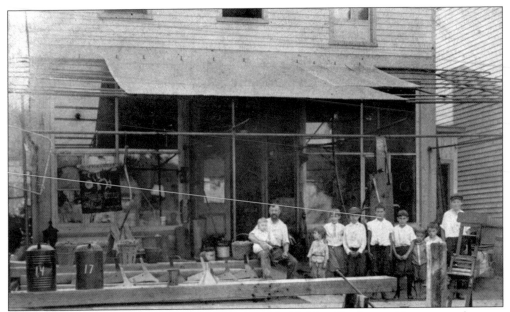

BOWDEN'S SECOND STORE. Harvey Bowden, seated, holds Merrill, who would grow up to become locally important as the developer of the first major airport in the area, Bowden Airport in Swan Creek. A letter written in January 1942 from Maryland governor Herbert O'Conor thanks Bowden for his "patriotic offer of the services of fifty pilots and seventeen light aircraft . . . for the Civilian Air Patrol Program." (Courtesy the Historical Society of Harford County, Inc.)

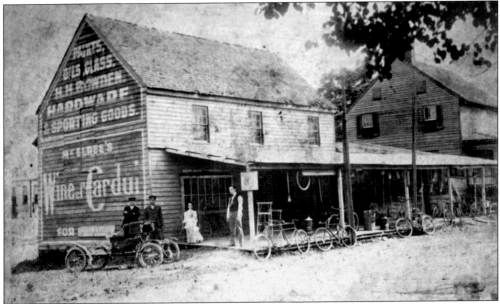

BOWDEN'S SPORTING GOODS STORE, 1902. Harvey and Ann (Maslin) Bowden owned this sporting goods store on Washington Street on the site of the Masonic Temple. Bowden and Richard Leitheiser almost drowned driving Bowden's car (the first in town) on the frozen Susquehanna, into a hole where ice had been harvested. Pictured from left to right are Mr. Bowden; Otis H. Cooper; Mrs. Bowden and son, Basil; and Joseph Simson. (Courtesy the Historical Society of Harford County, Inc.)

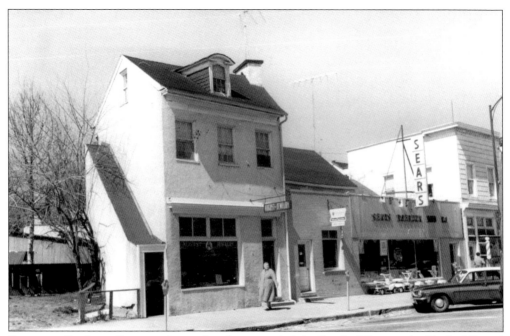

SHOPS ON ST. JOHN STREET. August Jewelers occupied the first building on the block, followed by an insurance agency, Sears, and Domenick's Barber Shop. Doodads has replaced the jeweler's store, and Sears is long gone, but Domenick's Barber Shop has remained as a revered St. John Street institution. (Courtesy James Wollon.)

HECHT'S HARDWARE. David Seibert worked in Hecht's Hardware from 1961 through his years at Harford Community College. Although Jake Hecht owned the store, David says that people asked for Jake's sister when they came in because she knew where everything was. (Courtesy James Wollon.)

WESTERN AUTO. After running the L&P Grocery Store on Union Avenue, Ralph Lawrence bought the Western Auto next to the Bata Shoe Store. The following photographs show other hardware stores that populated the streets of town over the years. (Courtesy James Wollon.)

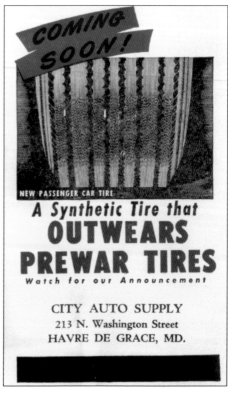

POSTCARD FOR CITY AUTO SUPPLY. This postcard was delivered to Merrill Bowden in 1941. The war demanded sacrifice but also gave a lot of new technology to society, as scientists experimented with new materials and chemicals to make combat materials and supplies last longer and work better. As the card proclaims, the postwar world would replace the old with synthetics and plastics. (Courtesy the Historical Society of Harford County, Inc.)

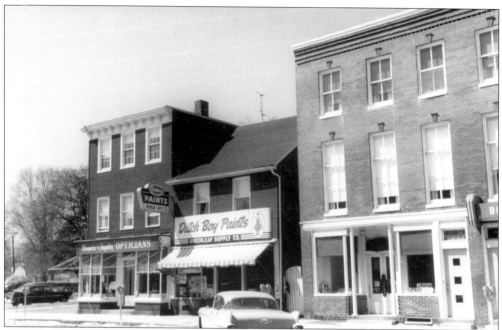

GREENLEAF SUPPLY COMPANY. "You're looking for who? Oh, if it's 2 o'clock, he's down at . . ." Every town has a few places where the old timers like to go and hang out. For many in Havre de Grace, it's a hardware store such as Greenleaf Supply, here in a 1950s photograph and still in business today. (Courtesy James Wollon.)

RIGLER'S. Rigler's Furniture burned down in a 1950s fire. The courtyard complex of small shops replaced Rigler's. Plans may be in place to replace the courtyard with a new hotel. (Courtesy James Wollon.)

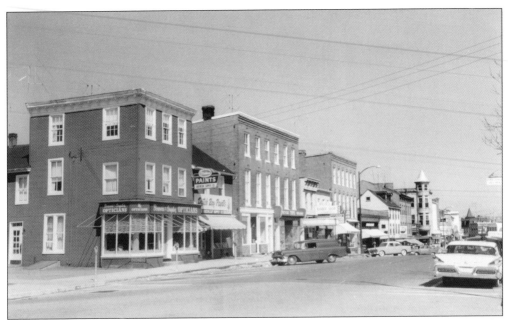

VIEW OF 100 BLOCK NORTH WASHINGTON STREET, WEST SIDE. One hundred years ago, the streets were unpaved; boards would be in place for sidewalks, as you see in Western movies. Teams of horses pulling huge wagons of wares would crunch along on crushed oyster shells covering the street to keep the dust down. Most of the buildings would be wooden frame structures similar in size to Greenleaf's Supply. (Courtesy James Wollon.)

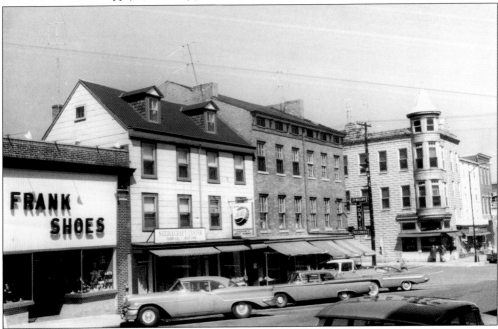

FURTHER DOWN 100 BLOCK NORTH WASHINGTON STREET, WEST SIDE. Frank Shoes has P. F. Flyers in the window. How could kids take gym class without a good pair of sneakers like P. F. Flyers or Keds? In the middle of the photograph is Correri's Fruit Market at the Pepsi sign. (Courtesy James Wollon.)

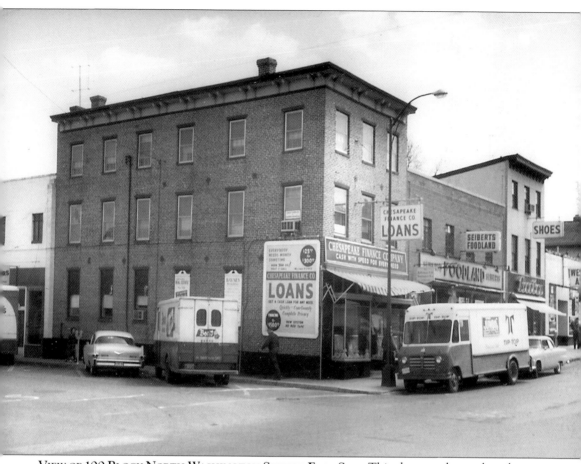

VIEW OF 100 BLOCK NORTH WASHINGTON STREET, EAST SIDE. This photograph must have been taken in the early morning, when store deliveries are being made. A truck from Tip-Top delivers bread and cakes to Seibert's Foodland, while a Bond Bread truck is around the side. Chesapeake Finance really pushed the loans. "Everybody needs money sometime—$25 to $300." "Cash with speed for every need." Baltimore Life Insurance has a shingle out. Bata Shoes, headquartered in Belcamp, had their store next to Ralph Lawrence's Western Auto. (Courtesy James Wollon.)

VIEW OF 200 BLOCK NORTH WASHINGTON STREET, WEST SIDE. The photographs in this chapter show the changes of inhabitants in a number of the buildings downtown. Many settle in for a while and close when their owners die, leave town, or want a change. The wonderful McLhinney Building, with its more intimate shop spaces, probably sees more tenant turnaround than most. (Courtesy James Wollon.)

SHAFER'S APPLIANCES. To the right of Shafer's Appliances was the one place everybody knew, McLhinney's News Depot. Some remember it as the only place in the county where you could buy the *New York Times.* To others, it was a place to catch up on the real news around town. (Courtesy James Wollon.)

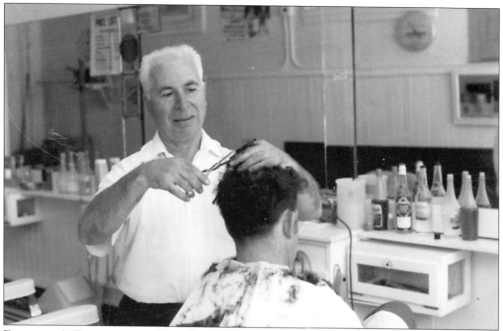

DOMENICK'S BARBER SHOP. This photograph begins a series of barbershops though the years. Domenick's opened at 314 St. John Street around 1933 and is still there, although Donato J. Saponaro, pictured, who opened the shop, died in 1954. His son has run it ever since. Many will remember Joseph Fisch, or Pippi, as everyone at the shop knew him. (Courtesy Glenn Higgins.)

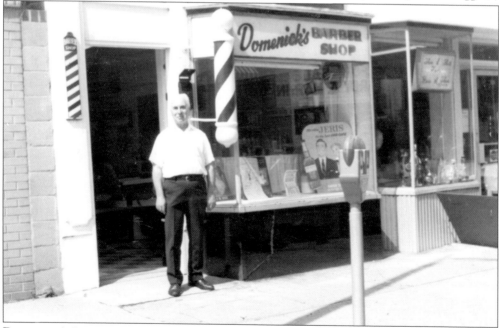

DOMENICK'S BARBER SHOP. The black marble veneer at the bottom of the shop's exterior, which at one time extended along the row of shops to the right, was destroyed by a driver who jumped the curb and crashed into a shop. The driver kept driving parallel to the curb, breaking the windows and busting the marble fronts of all the stores. (Courtesy Glenn Higgins.)

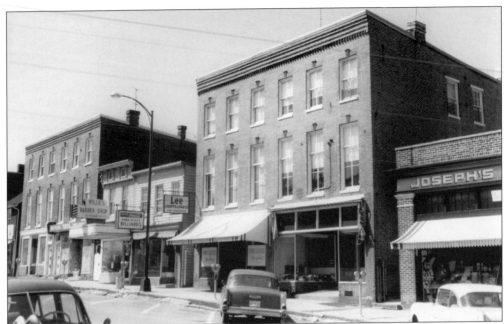

WILLIE'S BARBER SHOP. In this mid-1950s photograph, Willie's is where Bucchi's Shoes used to be, and the Park Plaza Billiards has moved in after Seibert's Grocery moved across the street. Joseph's Department Store, started by Joseph Silverstein, is now run by his son, Eli, who says that the building was originally an auto showroom. (Courtesy James Wollon.)

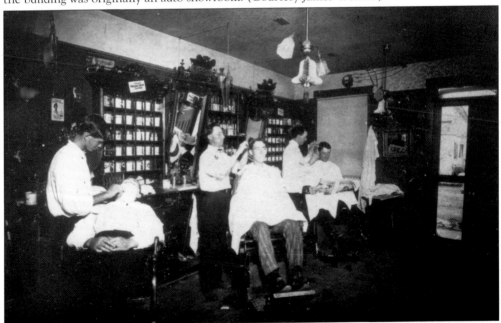

BARBER SHOP. Around 1900, this barber shop was in the street-level entrance of 200 North Washington Street, seen on page 70. On page 114 is a probably contemporary photograph of the White Chapel Pool Hall across the street. Look through the door of the barber shop—a bit of the White Chapel Pool Hall seems to be in view. The Dolly Mae women's shop is where Amanda's Florist is now. (Courtesy Green.)

BUCCHI'S SHOE SHOP. A look at the 1878 directory reveals a good number of stores. The bustling town had six bakers and confectioners, two barbers, nine boot and shoe dealers (including H. Levy), three butchers, three carpenters and undertakers (undertakers made the wooden caskets, so they were good with wood and usually made furniture as well; perhaps that is where Madison Mitchell, undertaker by trade, came by his woodworking skills with making decoys—a use of wood unique to a seaside town), four clothing and gentlemen's goods (again, Levy is listed), three druggists, five duck shooters, six fishermen (companies, not individuals), seven dealers in general merchandise, one hardware shop, four milliners and dressmakers, and one photographer (O. S. McFadden). (Courtesy David Seibert.)

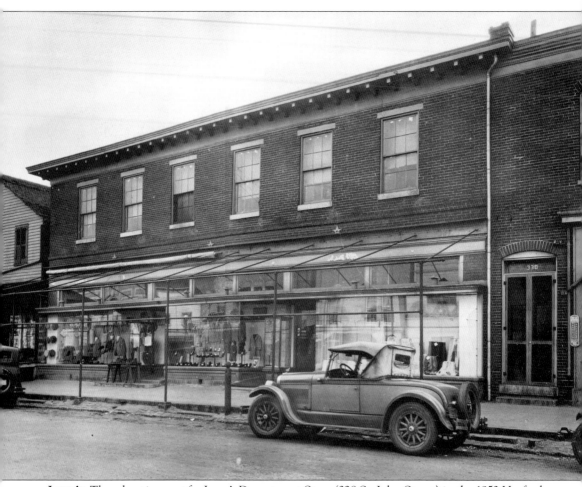

LEVY'S. The advertisement for Levy's Department Store (328 St. John Street) in the 1953 Harford County Directory says the store has given "78 years of faithful service to the public." That means it was founded in 1875. Not surprisingly, the store shows up in the 1878 Harford Directory under H. Levy for the clothing and shoe categories. The 1953 advertisement for Newmeyer's Department Store (220 North Washington Street) says the store had been established in 1878. There is no mention in the 1878 directory, so they must have opened right after publication of the book. For strictly men's clothing, one could go to Leithiser's (Franklin and St. John Streets). Brands that Levy's carried in 1953 included, for men: Bostonian shoes, Clipper Craft suits, Northcool suits, and Marlboro shirts; for ladies: Teena Paige junior dresses, Jonathan Logan, and Henry Rosenfeld Originals; for children: Red Goose shoes, Judy Kent blouses and skirts, and Rob Roy shirts. (Courtesy Richard Long.)

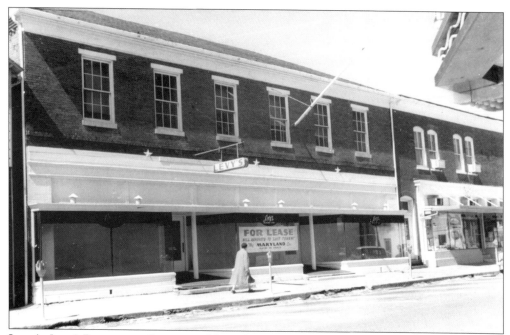

LEVY'S. Levy's Department Store moved from the St. John Street location in 1963. Lyons Pharmacy owned the Levy's building, so Dr. Lyons simply moved his pharmacy, which had always been right next door, to the more spacious area next door. In 1963, many neighborhood pharmacies were expanding to offer a wider range of merchandise. (Courtesy James Wollon.)

LYON'S PHARMACY

"The Rexall Store"

Established 1894

PRESCRIPTION SPECIALIST *Agency for* ZENITH HEARING AID

220 ST. JOHN STREET

LYONS PHARMACY ADVERTISEMENT, 1953. This advertisement is from the 1953 Harford County Directory. Lyons had competition from City Pharmacy (North Union Avenue and Franklin Street) and many more over the years. Lyons has survived to be one of the oldest remaining businesses in Havre de Grace. (Courtesy the Historical Society of Harford County, Inc.)

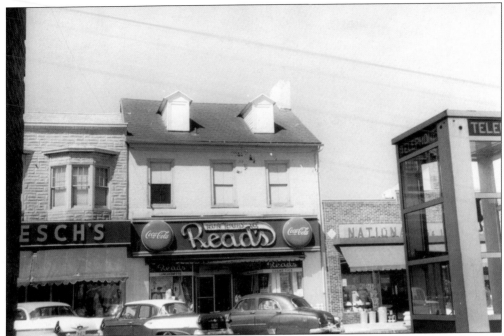

READ'S DRUG STORE. Everyone remembers "Run Right to Read's" as the slogan for the Baltimore-based chain of drug stores. In Havre de Grace, Read's was located in the Rodgers House. Years later, the building was restored closer to its original appearance outside and became the Rodgers House Restaurant. (Courtesy the Historical Society of Harford County, Inc.)

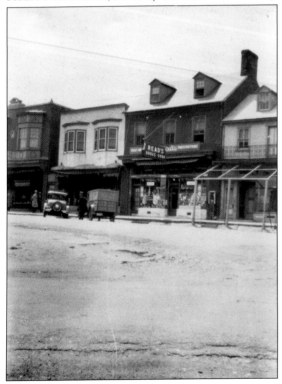

READ'S DRUG STORE. In this 1930s photograph, the building to the right of the Rodgers House, with similar gabled roof, is probably also some kind of storefront. By the time of the previous photograph, some 20 years later, the building is replaced by the low, brick National Store, probably because of the enemy of all early buildings—fire. (Courtesy the Historical Society of Harford County, Inc.)

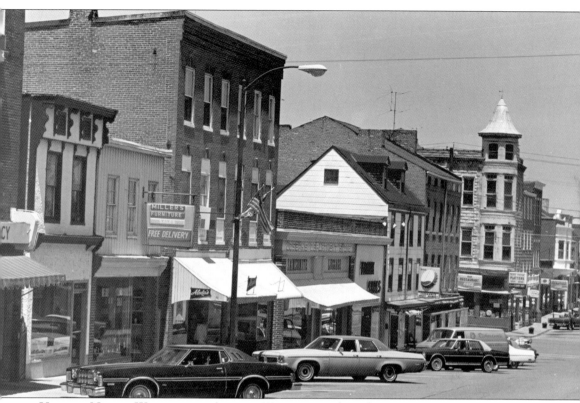

VIEW OF NORTH WASHINGTON STREET, WEST SIDE. This relatively recent photograph from the 1980s shows just how much can change in about 25 years. From left to right, there is a travel agency, a jewelry or coin shop, Aleda's shop for women's clothing, Joseph's Department Store, Frank Shoes, Correri's Fruit Market, and various eateries. The same block on the 1878 map shows a dozen stores with Nixon's Hotel on the corner, this side of Pennington Avenue (St. Clair Street back then). There were three hotels in town in 1878: in addition to Nixon's, owned by James Nixon, there was the Harford House (where St. John Street meets Union Avenue), owned by Mrs. B. M. Reasin, and J. P. Adams's U.S. Hotel at St. John Street and Pennington Avenue. No fewer than 12 stores sold groceries and provisions. (Courtesy James Wollon.)

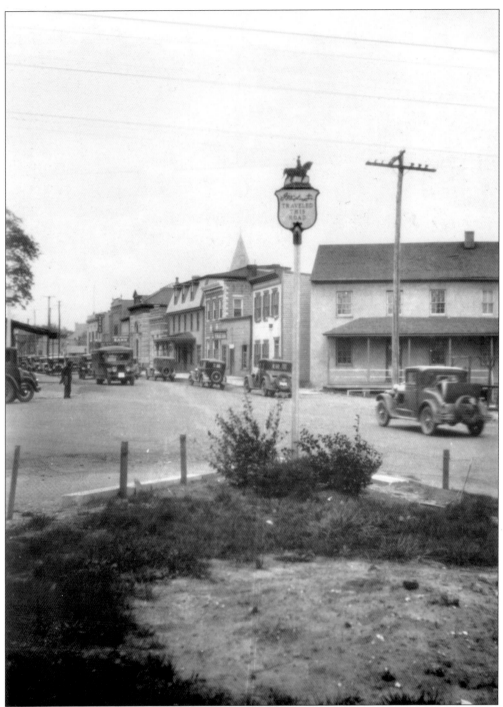

VIEW OF ST. JOHN STREET. This little triangular patch is curious. Photographs such as this 1930s view always show the space cordoned off in some way—by poles or by ropes. Today it is nicely terraced and landscaped with sidewalks and benches. The Washington sign is still in the same spot, although George's head has been knocked off. (Courtesy the Historical Society of Harford County, Inc.)

VIEW OF ST. JOHN STREET. Clyde Mitchell's house, next to the bank addition, became a two-story furniture store and warehouse. After a fire in the early 1950s, a group of small buildings with a courtyard in between was built. Courtyard Books and Christmas Magic are two current occupants. (Courtesy James Wollon.)

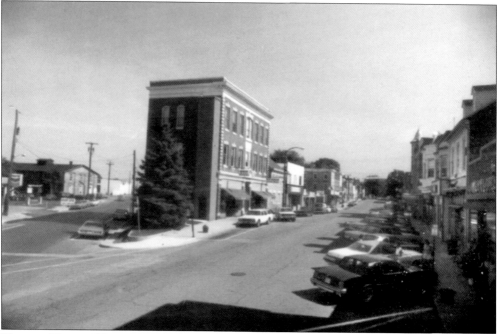

VIEW OF NORTH WASHINGTON STREET. This early 1980s photograph shows a huge tree at the meeting of St. John and North Washington Streets, where the Old Post Road sign of George Washington is. (Courtesy James Wollon.)

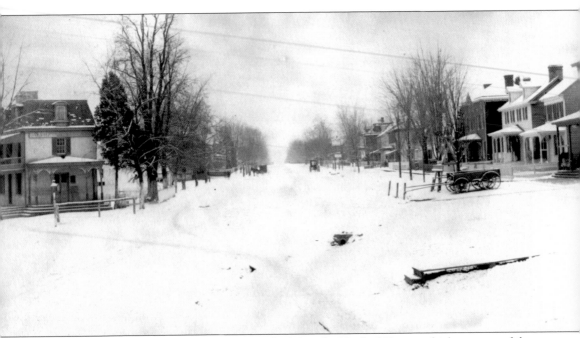

VIEW OF UNION AVENUE IN WINTER. To the left is the Harford House, which was one of three hotels listed in the 1878 directory. This photograph is about 10 years later, but perhaps Mrs. Reasin still owns it. Note the hitching posts by the hotel and along the street on Union Avenue to the right and center of the photograph. A buckboard wagon sits to the right. Union Avenue seems to be mainly homes at this time, with a few stores working themselves in about three blocks down, just before the intersection with Pennigton Avenue and St. Clair Street. (Courtesy the Historical Society of Harford County, Inc.)

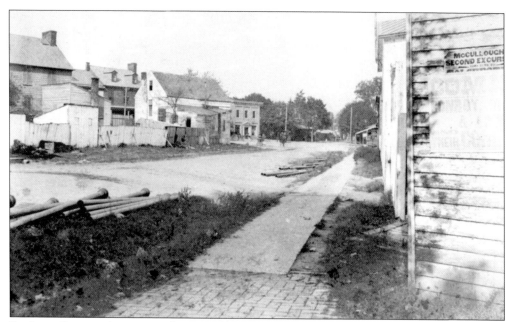

ST. JOHN STREET. A poster reads, "McCullough's Second Excursion this time to Tolchester." This is for a steamboat ride, a popular diversion in the 19th century and beyond. Carrie Lawrence remembers that after she and Ralph Lawrence married in 1936, they'd take their boat, the *Wee Three*, to Tolchester: "There was lots of drinking, soft and hard crabs and fish. The Bay waters were so clear, you could see the bottom." (Courtesy James Wollon.)

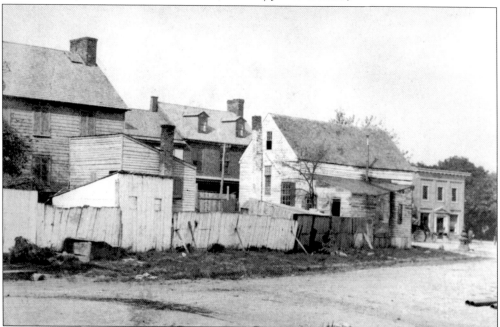

A CLOSER VIEW OF ST. JOHN STREET. Both photographs on this page show the same scene: a view of the west side of St. John Street from the water side, showing part of the buildings on North Washington Street beyond. One of the buildings is the Rodgers House. The pipes in the street are being readied to lay the first water system. (Courtesy James Wollon.)

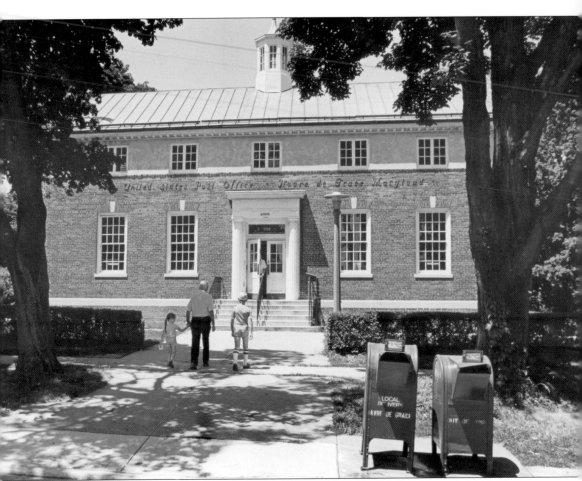

UNITED STATES POST OFFICE. The post office pictured was on North Union Avenue in the heart of town. It was sold in the past few years and has been modified for medical offices. The fine brick structure with tin roof was designed in the Colonial style as a tribute to the importance of that era to the town. It replaced a stone building from before the turn of the century. The new post office is at 301 North Juniata Street, on the same property as the old B&O station, which is a nice turn, considering the mail would be delivered from out of town by train. (Courtesy James Wollon.)

VIEW OF PENNINGTON AVENUE. Pennington Avenue is the renamed St. Clair Street where the Cut had been, the railway spur that allowed the train to go down to the dock, pick up freight, and rejoin the main track. The track bed was filled in, the road paved, and the name changed. Today the Visitor's Center and Police Department are located on Pennington Avenue. (Courtesy James Wollon.)

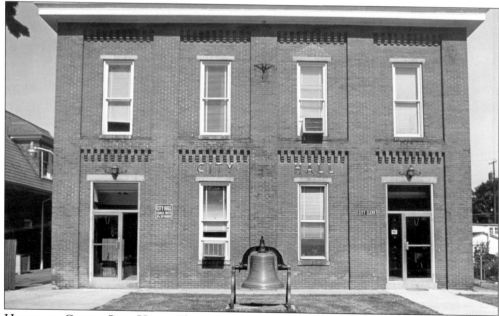

HAVRE DE GRACE CITY HALL. The original Havre de Grace High School was built in 1896. When the new school was built, the elementary grades took over the building. When the new elementary school was built, the 1896 structure was razed. The bell, the bell-ringing mechanism, and the cornerstone from the building were donated to the city with enough granite slabs so that the bell could be mounted on a base in front of the city hall. (Courtesy James Wollon.)

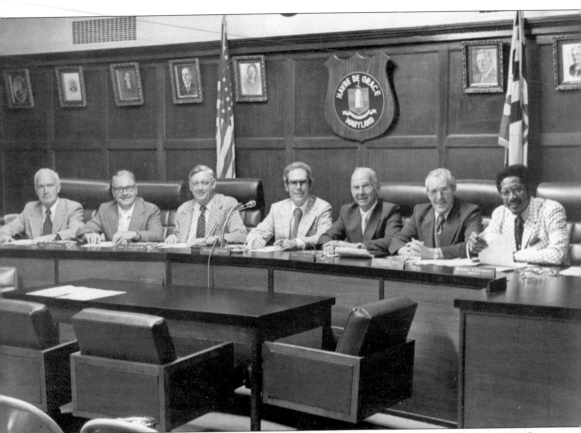

HAVRE DE GRACE CITY COUNCIL. From 1973 to 1978, in three successive terms as mayor, Frank Hutchins and the Havre de Grace City Council began the slow process of turning the town around. Over the course of the previous 50 years, Havre de Grace had suffered a series of blows to its economy and its spirit. The opening of the Conowingo Dam in 1927 meant the sudden loss of the fishing industry and the slow dying out of the waterfowl industry. In 1933, the repeal of Prohibition dried up the glory days of some of the speakeasies, such as the Hotel Bayou. The gambling industry continued to flourish, but the closing of the race track in 1950 put a dead halt to gambling visitors from neighboring states. In 1963, Interstate 95 replaced Route 40, allowing travelers to bypass Havre de Grace completely for the first time. How could Hutchins and crew do it? Pictured from left to right are J. Emerson Craig, "Flick" Montville, Jack McLaughlin, Mayor Frank J. Hutchins, Robert K. Whitney, William P. Dietz, and Wardell V. Stansbury. (Courtesy Cathy Vincenti.)

BEAUTIFYING DOWNTOWN.
Sometimes people have to stop talking about improvements and start doing little things to make a difference. That's what these folks did to get people to notice how attractive downtown could be. Skeptics weren't sure Havre de Grace should be improved if it meant a change in their way of life. Could the town have beautification, tourism, and keep its way of life? (Courtesy Richard Tome.)

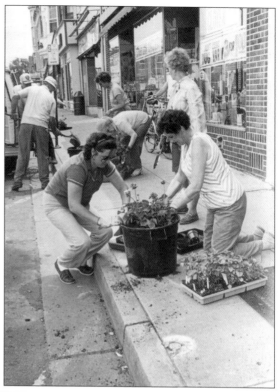

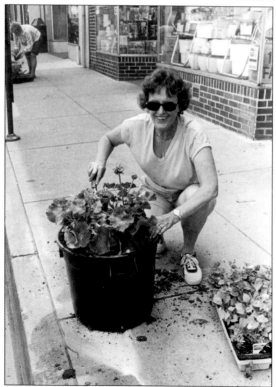

BEAUTIFYING DOWNTOWN. It's hard to take a town away from people if they're the ones making the decisions and directing the changes. Beginning with the determination of Mayor Hutchins to improve the city, the next few mayors and their city councils, for better or worse (depending, as always, on whose opinions are being expressed), repaved, unpaved, or paved over major sections of the downtown area and began the development of outlying areas of town. (Courtesy Richard Tome.)

85

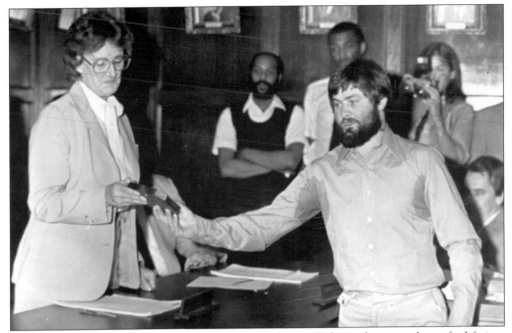

JEAN ROBERTS RETIREMENT. Richard Tome awards Jean Roberts the equivalent of a lifetime achievement award on behalf of the Havre de Grace City Council for her efforts in improving the city. In the 1878 Harford Directory, one florist is listed, Aquilla Treadway. Richard Tome opened the County Flower Shop in 1971. (Courtesy Richard Tome.)

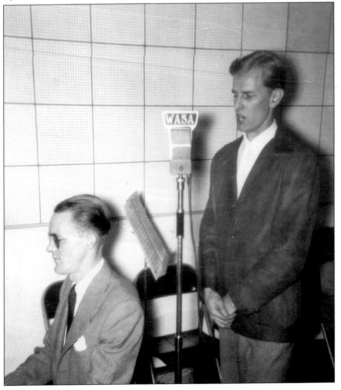

LAWRENCE HARRISON (LEFT) AND ED BAKEY AT WASA RADIO. Patron saint of a recent entertainment boom, Havre de Grace–born Ed Bakey (right) began a long entertainment career as Pop-Pop, a WJZ-TV children's show character. He had movie roles in *The Philadelphia Experiment, For Pete's Sake,* and *The Sting,* and was a television mainstay with appearances in the mini-series *Centennial, Gunsmoke, Charlie's Angels, Starsky and Hutch, Star Trek,* and many more. (Courtesy David Seibert.)

Six

HOME AND CHURCH

THE VEGETABLE TRUCK. "That's my mom, hair up and smoking." That's how Brenda Baker introduced this photograph of her mother. Folks of a certain generation might remember their mothers doing really grimy housework. We'll see why over the next few pages. This book includes photographs from the album of Dr. Alexander Stewart Koser of Havre de Grace. He took or had taken an album of some 34 photographs that have been dated between 1884 and 1894. The album was given to the Historical Society of Harford County. A number of very early postcards of Havre de Grace were based on some of the same photographs in the album, so it is possible that this was a commercial product. No indication is presented on the album itself, and the album is still intact. Whatever the case, the Koser album represents a photographic and historical treasure. For a complete list of Koser images used in this book, visit www.harfordbooks.com. (Courtesy Brenda Baker.)

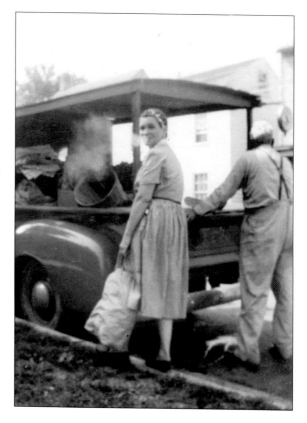

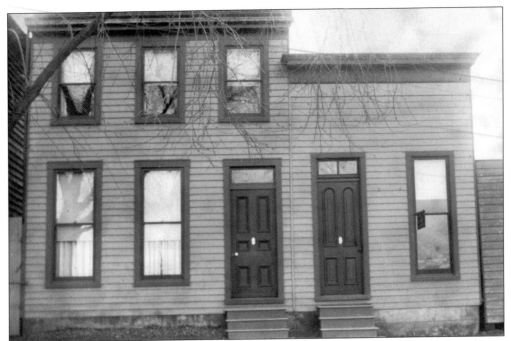

HOME AND DENTAL OFFICE OF DR. ALEXANDER STEWART KOSER. This two-story frame house and single-story frame office stood at 115 and 114 St. John Street on the west side of the street. Today 416 is the address. (Courtesy the Historical Society of Harford County, Inc.)

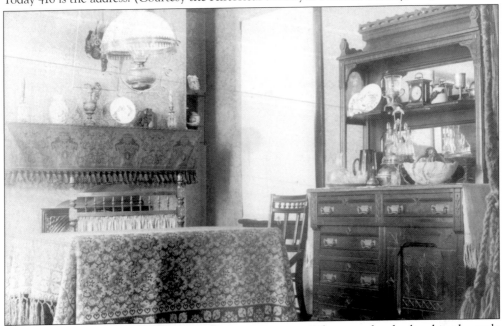

HOME OF DR. ALEXANDER STEWART KOSER, INTERIOR. When people who lived in the early years of the 20th century say their family didn't have much, we don't really understand. In this photograph, some of Dr. Koser's household items are on display. His fine material possessions show that he had achieved a certain measure of wealth. By contrast, poor families has only the barest essentials. (Courtesy the Historical Society of Harford County, Inc.)

HOME, 715 STOKES STREET. Florence Brennan hangs clothes on the line. Monday was always laundry day. Here, as in certain areas of Havre de Grace, indoor plumbing was one cold-water faucet, and bathrooms hadn't yet moved indoors. The Brennans had a water closet on the back porch, back under the stairs. It was cold but it flushed. (Courtesy Brenda Baker.)

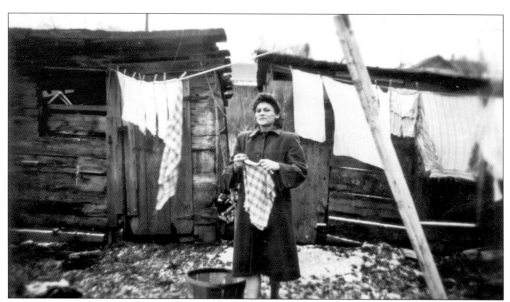

BACKYARD, 715 STOKES STREET. Wringer washers were the norm, and the sun dried the family's clothes. Notice the fruit basket that served as the clothes basket. There was no Rubbermaid until the 1950s. But even then, who could afford Rubbermaid when a fruit basket would do? (Courtesy Brenda Baker.)

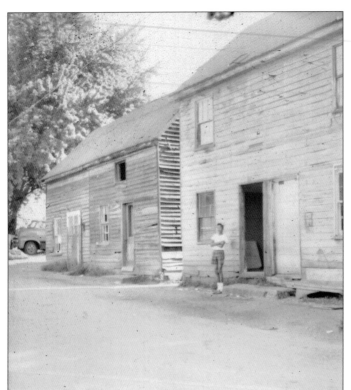

RESIDENCE, STRAWBERRY ALLEY. In the 1940s, Mitchell Builders consisted of Ellsworth Shank and Mitch Mitchell. Here they are renovating a house on Strawberry Alley to become their headquarters. Ellsworth was the bookkeeper. They rented the house for $15 per month. (Courtesy James Wollon.)

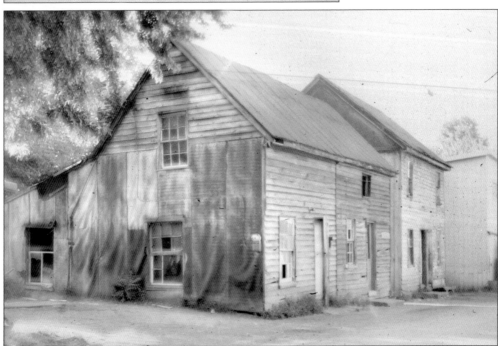

RESIDENCE, STRAWBERRY ALLEY. Today's street names that end in "Lane" once ended in "Alley" and denoted streets in town where African Americans lived. The Strawberry Alley homes shown here are examples of such ramshackle living. (Courtesy James Wollon.)

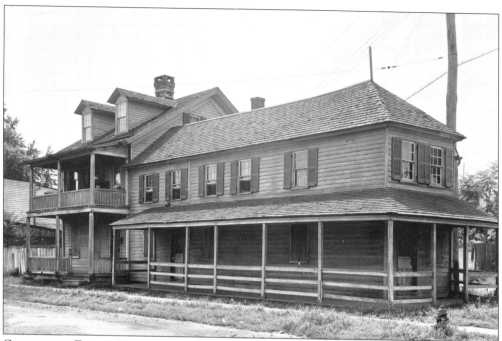

CONNECTED FRAME HOUSES, ST. JOHN'S STREET, AUGUST, 1936. Carrie Lawrence, born in 1907, grew up on Fountain Street in a row house with coal heat and electricity for lamps only. She remembers when the streets were unpaved, and the walkways were boards. Her brother found some change and hid it under the boards. It was easier than finding a place to hide it indoors. (Courtesy Library of Congress.)

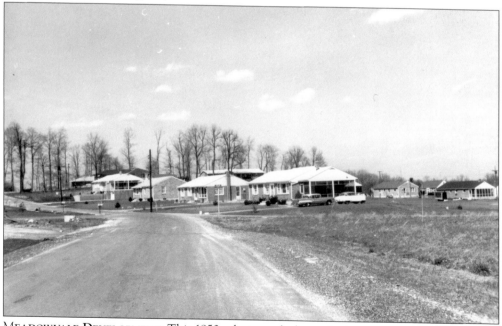

MEADOWVALE DEVELOPMENT. This 1950s photograph shows the intersection of Wakefield and Drew Drives in the then-new neighborhood of Meadowvale, one of the first areas on the "outskirts" of town to be developed. The elementary school opened in 1959. (Courtesy James Wollon.)

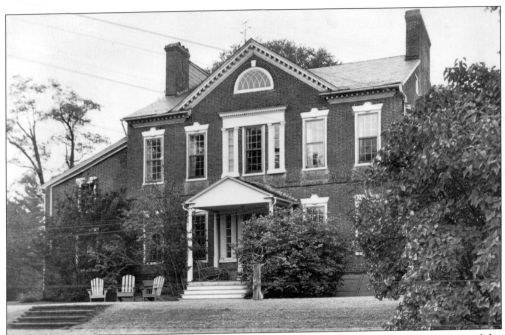

SION HILL, SEPTEMBER 1936. Sion Hill, built in 1775, has been home to five generations of the Rodgers family of naval fame but began life as a school for boys. John Rodgers, great-grandson of Commo. John Rodgers of the War of 1812, fought in World War I in the Pacific. He was taught to fly by the Wright Brothers and was the second naval aviator in the United States. (Courtesy the Historical Society of Harford County, Inc.)

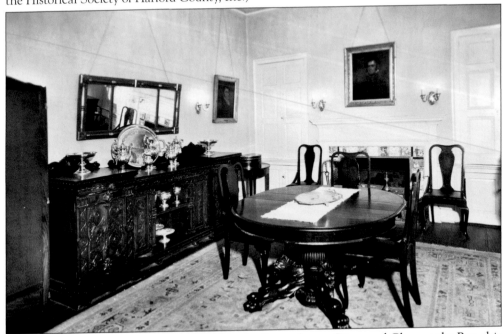

MOUNT PLEASANT, INTERIOR. Overlooking the Susquehanna River and Chesapeake Bay, this home was built in 1757 and was the summer home of William Paca, one of Maryland's signers of the Declaration of Independence. (Courtesy the Historical Society of Harford County, Inc.)

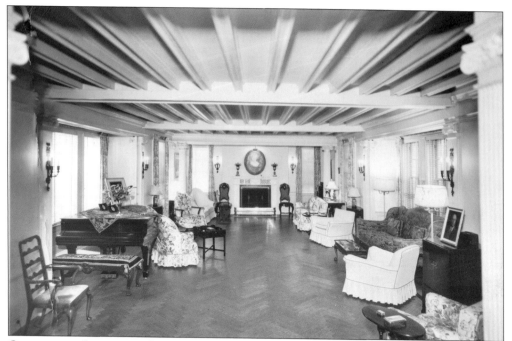

OAKINGTON, INTERIOR. The home of Millard Tydings looks every bit as balanced and refined as he comported himself in public. He dressed well and, some said, assumed a patrician air. This elegant yet understated room is a reflection of the man. His photograph is on the table at right. (Courtesy the Historical Society of Harford County, Inc.)

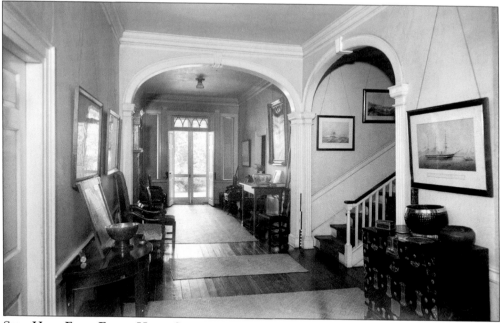

SION HILL, FIRST FLOOR HALL, SEPTEMBER 1936. As befits a family of navy heritage, the prints on the walls are all of ships. In fact, six ships have been named in honor of the three generations of fightin' John Rodgers, three as USS *John Rodgers* and three as USS *Rodgers*. (Courtesy Library of Congress.)

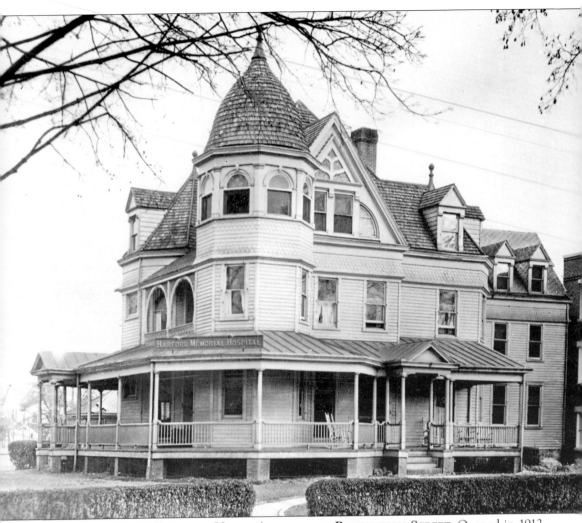

HAVRE DE GRACE HOSPITAL, UNION AVENUE AND REVOLUTION STREET. Opened in 1912, the hospital had the air of other grand Victorian homes in Havre de Grace because it began life as one; it had been the 21-room residence of the George Baker family and was sold to the hospital directors for just over $10,000. In 1942, ground was broken in the same block for the first section of the modern Harford Memorial Hospital, which eventually gobbled up the space around the old hospital and finally the old hospital itself. (Courtesy the Historical Society of Harford County, Inc.)

ANGEL HILL, OTSEGO STREET. The home was built in two stages—not unusual as families grew, or as living standards changed and more space was desired, if not needed. This photograph captures the earlier frame and stucco wing. Angel Hill is also the name of the cemetery where such local luminaries as Millard Tydings and John O'Neill are buried. (Courtesy Library of Congress.)

ANGEL HILL, OTSEGO STREET. This photograph shows the newer, brick wing of the home. Brick homes cost more, but held up better in most cases. Sadly the house was left to deteriorate and was demolished. Also buried at Angel Hill is John Donahoo, who built some 12 lighthouses in the Chesapeake Bay during the early to mid-19th century, including Concord Point at Havre de Grace and nearby Poole Island. (Courtesy Library of Congress.)

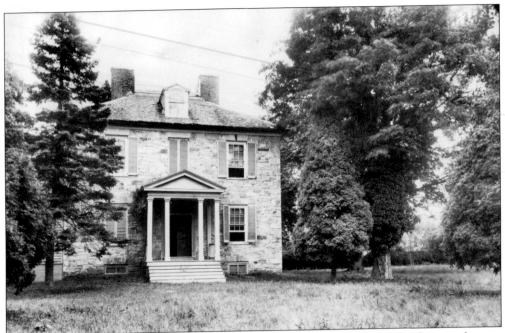

OAKINGTON, FRONT VIEW. This and the next image are from two postcards. The photographs were taken in the very early 20th century. The Oakington estate was bought in 1905 by a flamboyant New Yorker named Jimmy Breeze. He threw parties with nude dancing girls jumping out of cakes. (Courtesy the Historical Society of Harford County, Inc.)

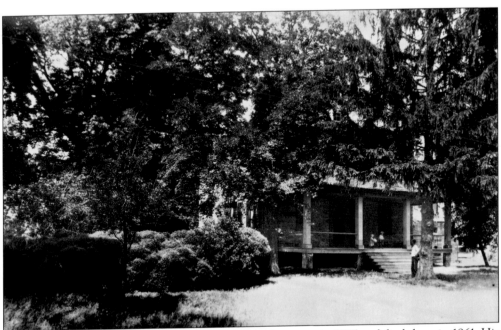

OAKINGTON, BACK VIEW. Millard Tydings bought the estate in 1935 and died there in 1961. His family sold off pieces of the property over the years, including the Swan Creek Country Club and Ashley, the rehab center. (Courtesy the Historical Society of Harford County, Inc.)

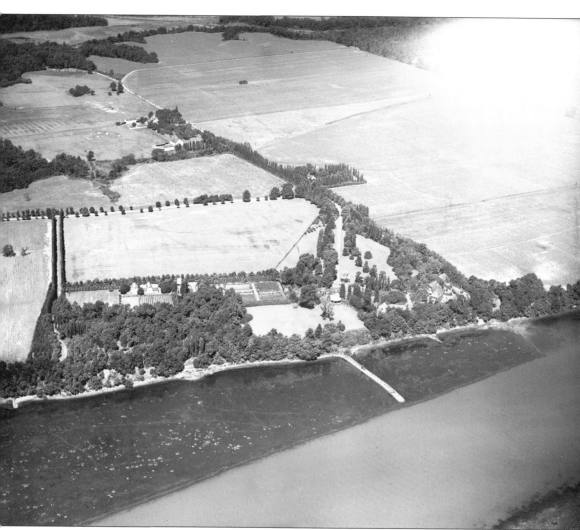

AERIAL VIEW OF THE OAKINGTON ESTATE, SEPTEMBER 5, 1927. At this time, the estate was owned by "Commodore" Leonard Richards, another New Yorker. He dredged the river to moor his 160-foot steamship at the dock you see. Richards died of a heart attack in 1933. The place was bought for a boys' school that never saw fruition. In 1935, Tydings, then 45 years old, bought the estate, married, and adopted his wife's two young children by a previous marriage. He spent some of his most productive and most disappointing years in and out of office while at Oakington, and he saw his son, Joe, begin his political career. He died just days before President Kennedy appointed Joe U.S. attorney for Maryland. He is buried in Angel Hill Cemetery along with his ancestor, John O'Neill. (Courtesy Hagley Museum and Library.)

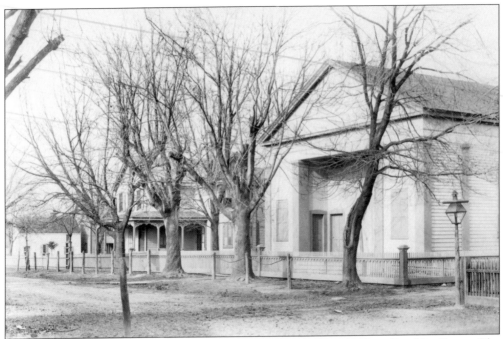

PRESBYTERIAN CHURCH. The Presbyterian Church was built in 1840 on Franklin Street. The manse was built about 1890 on Stokes Street. In 1917, the church board was meeting and, in a move that still ruffles some feathers, they locked out the minority interest in a hotly contested issue. (Courtesy the Historical Society of Harford County, Inc.)

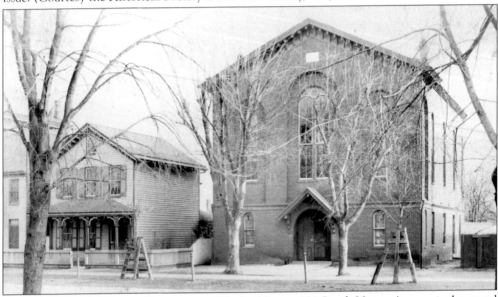

METHODIST CHURCH AND PARSONAGE. The building at 101 South Union Avenue is the grand replacement for the original seen in this photograph. George Borneman paid for the land and the church to be built with the stipulation that the original church be turned into apartments, which he named the Borneman Apartments. The new church is of Port Deposit granite with slate sidewalks from the North Harford slate fields. (Courtesy the Historical Society of Harford County, Inc.)

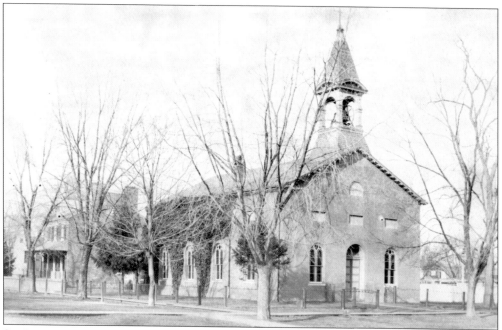

St. John Episcopal Church. The current church dates back to 1833, when it had been rebuilt after a fire in 1831. The congregation dates back to 1809, when William Stokes gave the church the land at Congress Street and Union Avenue. (Courtesy the Historical Society of Harford County, Inc.)

St. Patrick's Church Hall. The original wooden church was at the Mount Erin Cemetery location. The building pictured was built in 1847, replaced by the larger church in 1907, and converted for meeting space. The church built a new hall recently to replace this building. Mitch Mitchell recalls a shoe factory where the new hall was built and bowling apples that grew there to make girls trip and fall down. (Courtesy James Wollon.)

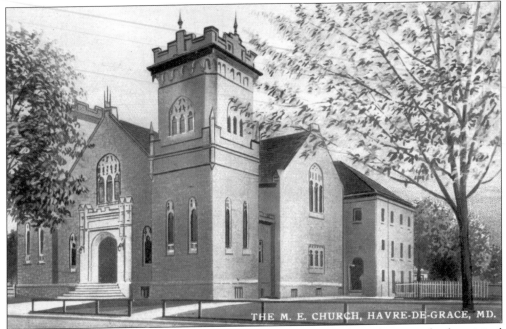

THE M. E. CHURCH, HAVRE-DE-GRACE, MD.

METHODIST CHURCH. This rare postcard image of the new church, the replacement for the original Methodist Church seen on page 98, was created when construction still had to be completed. The steeple, visible today and in the photograph below, has not yet been added. (Courtesy Ellsworth and Madelyn Shank.)

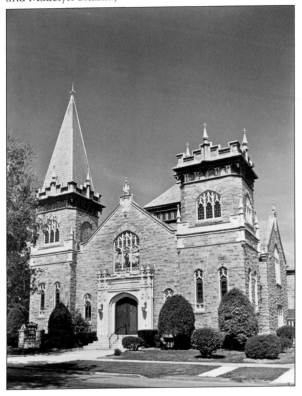

METHODIST CHURCH. This photograph from the 1960s shows the completed church. The Methodist Church has been serving the community since before the burning of Havre de Grace. The most striking aspect of this church is its beautiful structure. The Port Deposit granite walls and towers are strong and reach to the heights. The beautiful marble columns and arched ceiling are designed to lift the eye and thoughts heavenward. (Courtesy James Wollon.)

100

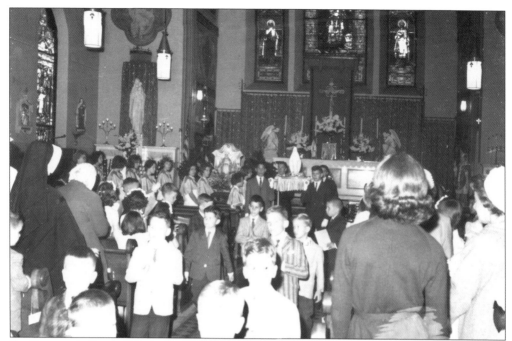

ST. PATRICK'S FIRST COMMUNION. The First Holy Communion ceremony is a solemn one for the Catholic children of St. Patrick's, including a May ceremony where the statue of the Blessed Virgin Mary is carried in procession around the church and outside as a way of acknowledging the special blessing of the sacrament of communion. (Courtesy David Seibert.)

GRADUATION PHOTOGRAPH. Since there was no Catholic high school in the area, when the public-school students of St. Patrick's families graduated from Havre de Grace High School, the pastor of the church held a special graduation recognition ceremony for them. David Seibert's sister is pictured in the first row, fourth from the left. (Courtesy David Seibert.)

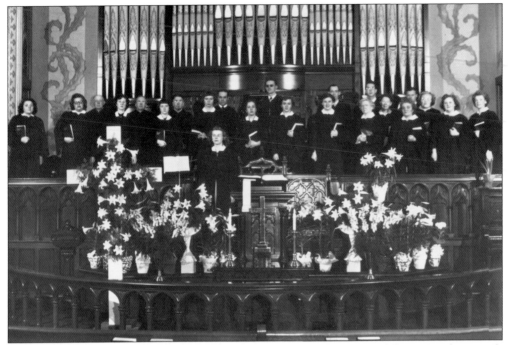

METHODIST CHURCH CHOIR. Easter is the biggest holy day of the year, and this 1950s photograph of the Methodist choir loft shows the area full of lilies, the traditional Easter flower. David Seibert's mother was organist for the choir. (Courtesy David Seibert.)

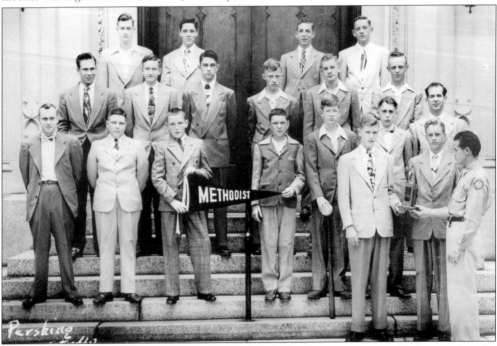

METHODIST CHURCH. The Methodist Church baseball team receives a trophy for winning the Methodist League championships. The love of baseball was not restricted to recreational leagues, but extended to the schools, churches, and work teams. (Courtesy Glenn Higgins.)

Seven

SCHOOL AND SPORTS

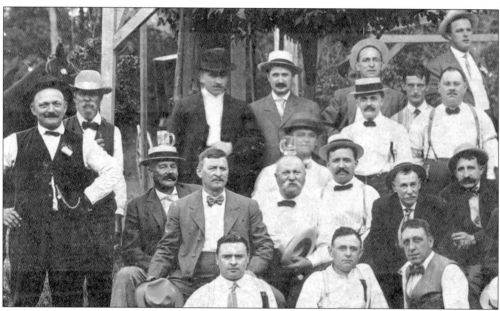

HAVRE DE GRACE RACE TRACK GRAND STAND (DETAIL). Here is a portion of the full photograph on page 110 and 111, which is incredible for several reasons. The sheer size of the original, 11 by 14 inches, is unusual, and allows for amazing scope and detail. The picture belonged to the man who was trumpeter at the races and must have been present at countless gatherings of the jockeys. Think of the wins and losses, the tosses and tragedies he must have witnessed. The photograph shows the original grandstand before it burned. We have many later photographs of the rebuilt grandstand but very few from before the fire. The focus isn't really on the grandstand—you only see the side of the structure; it's on the marvelous cast of characters that must have worked there. From the band in the top of the stands; to the bartender in the middle right; to the zany, serious, sodden, self-important crew arranged standing, sitting, and lounging in front of the camera. It's a study in character, with just about every type of humanity reflected in this race house mirror. (Courtesy Rita Ingram.)

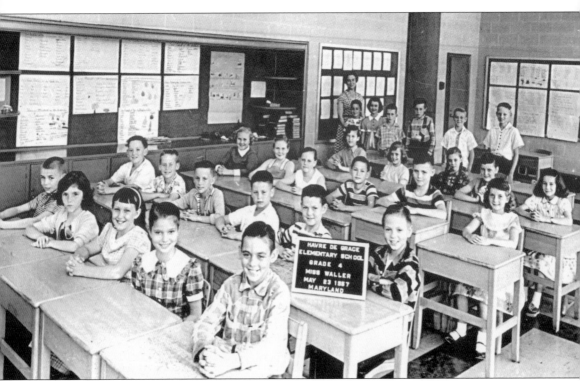

HAVRE DE GRACE ELEMENTARY FOURTH GRADE CLASS, MAY 23, 1957. In the early years in the life of a town like Havre de Grace, a century can go by with no drastic changes. In the past century, however, a few decades can make a vast difference in lifestyle and in the appearance of the place. When Carrie Lawrence was little, around 1914, her mom worked at a weaving mill where Huber's is now. It was owned by the Gambrills, who were comparatively rich, and they made rugs. Her mom worked the loom. Carrie played on the school grounds when they lived on Fountain Street. By about 5:00 p.m., she could smell dinner cooking, and she knew she'd have to go home. Folks ate three times a day, if they were lucky, so the smell of home cooking was a thing to savor. For Carrie, the sights and sounds she recalls as a school-age child were simple: the smell of dinner cooking, the school bells that started and ended the day, and on icy winter days, kids accepting a dare to touch the metal bars of the school's fence with their lips or tongue—and getting them stuck. (Courtesy Glenn Higgins.)

HAVRE DE GRACE ELEMENTARY SCHOOL. Happy students surround their teacher. This was the new elementary school, opened in 1950 to replace the old elementary school, which was actually the first high school built in Havre de Grace in 1896. The gym for the new high school was built on the site of that first high school, which had been razed, the basement filled in, and the lot leveled off. The auditorium was built in 1976. (Courtesy Brenda Baker.)

HAVRE DE GRACE ELEMENTARY SCHOOL PLAYGROUND. Built in 1896, the original school was described by its contemporaries as being a "handsome, well-lighted, well-ventilated building," and was referred to, at that time, as the "High School," even though it also housed the elementary students. Within a few years, the building had become overcrowded, and children in some of the lower grades had to have class in other places in town. As a result, in 1905, a four-room addition was built, and all Havre de Grace students were once again in the same building. (Courtesy Brenda Baker.)

HAVRE DE GRACE ELEMENTARY SCHOOL, JUNE 1958. In 1954, the Board of Education decided that the old high school was ill-suited to more modern educational needs and was a very real safety hazard to the residents of Havre de Grace. Thus they decided to raze the building that had served the community for over 50 years. The building was burned to the ground on Saturday, October 2, 1954, while a large crowd looked on. The following two days were spent in tearing down the brick walls and two very stubborn smokestacks. The two photographs on this page show some high-spirited fun as the elementary school students square dance (above) and race around the Maypole (below). (Courtesy Brenda Baker.)

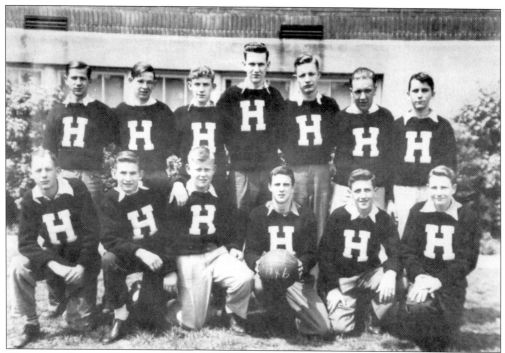

HAVRE DE GRACE HIGH SCHOOL BASKETBALL TEAM. The Tigers 1945–1946 basketball team from left to right are (first row) Bob Miller, George Pritts, ? Ramey, Jim Kenower(?) Coakley, Sonny Jefferson, and ? Ramey; (second row) Bob Kalonski, Merritt Hadry, Boyer Forsythe, Noble Mentzer, Bill Coakley, and Emory Purdom. (Courtesy Glenn Higgins.)

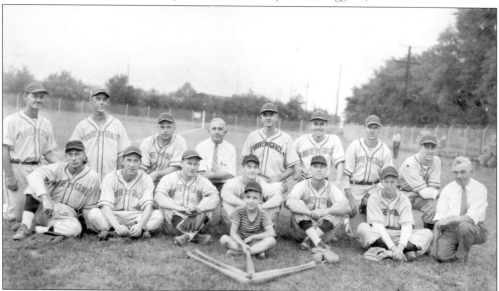

HAVRE DE GRACE SUSQUEHANNA LEAGUE BASEBALL TEAM. From its inception in the late 19th century, baseball was a popular regional sport—but a segregated one. The Negro League produced the great Ernest Burke, born in Havre de Grace. During his tour in the Pacific as one of the first black U.S. Marines in World War II, he earned a medal as a sharpshooter and began to play baseball. (Courtesy Glenn Higgins.)

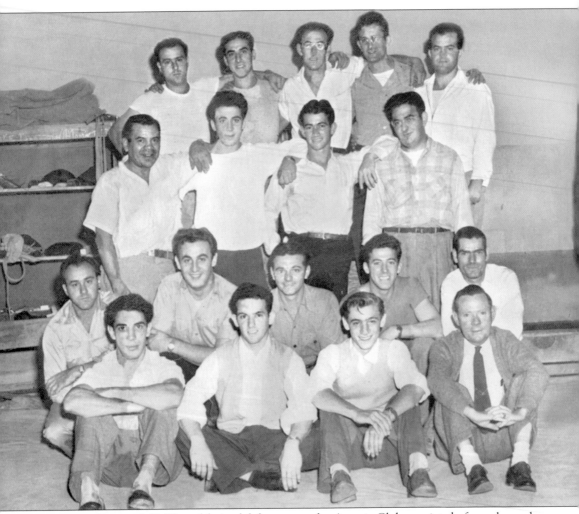

ATOMIC CLUB, 1947. The athletic club known as the Atomic Club consisted of members who were from the Italian neighborhood. Pictured from left to right are (first row) Johnny Languis, Angelo "Junior" Vincenti, Biaggio "Chick" DiMauro, and Russell Abbott; (second row) Jesse Bungori, Frank DiMauro, Tony "Flick" Gatto, Johnny Vincenti, and Russell "Dinky" Sprouse; (third row) Jim Wilson, Tony "Patch Eye" DiMauro, Frances Vincenti, and Frank Tarquini; (fourth row) Nanno Leodore, Robbie Gatto, Sam Gatto, Tony DeLorenzo, and Paulie Bungori. (Courtesy Glenn Higgins.)

"Papa Joe" Bernardi. This photograph of Joe Bernardi was taken around 1974, after his days as fight trainer for the Atomic Club and as one of Boom-Boom Lester's trainers. In fishing as in boxing, Papa Joe brought in the big ones. (Courtesy Glenn Higgins.)

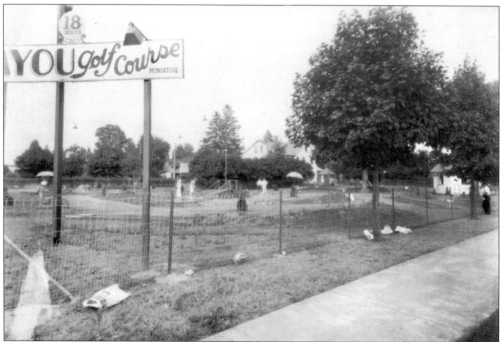

Bayou Miniature Golf Course. The Bayou Hotel was a notorious place in the days of Prohibition. Later, as if to atone, it became a convent, and later an apartment building. That's when Bayou Miniature Golf at Giles Street and Strawberry Alley was popular. (Courtesy Glenn Higgins.)

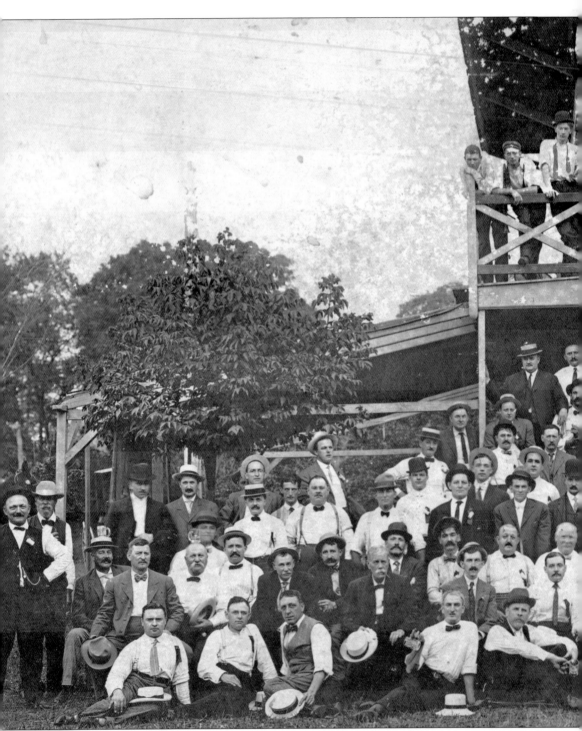

Havre de Grace Race Track Grand Stand. The facts are simple enough. The race track operated from 1912 to 1950, except for the war years from 1943 to 1945. In those 38 years, the track saw the legends pound the earth: Man O' War, Extermination, Equipoise, War Admiral, Discovery, Citation, and of course, Seabiscuit. The grandstand faced the bay. In 1951, the

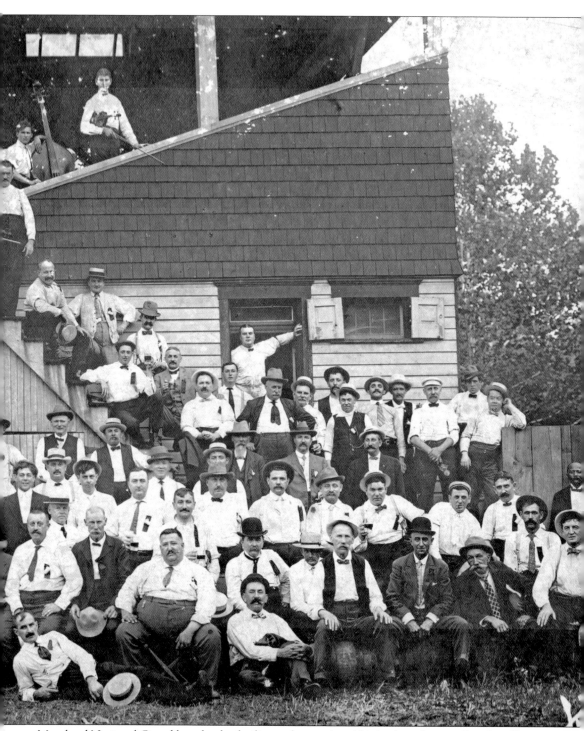

Maryland National Guard bought the facility and recently sold it back to the city. But the effect the track had on the town is like a story from Elliot Ness and the Untouchables. In fact, Havre de Grace had a nickname befitting the criminal activities that took place there: Little Chicago. (Courtesy Rita Ingram.)

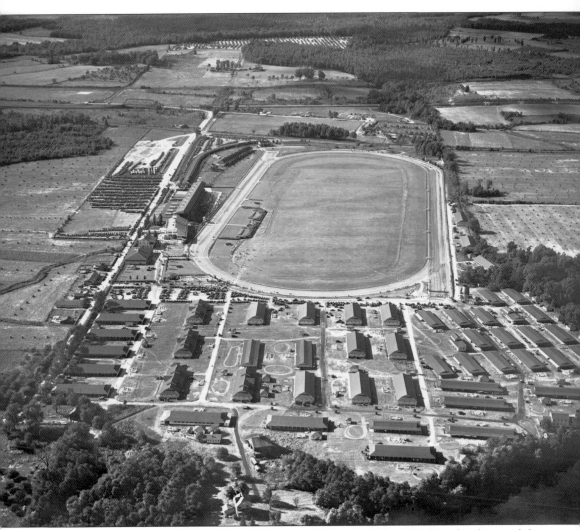

AERIAL VIEW OF HAVRE DE GRACE RACE TRACK, SEPTEMBER 29, 1931. David Seibert said that when his dad moved their grocery store to the Bayne Building at 137 North Washington Street in 1954, the upper floor, which had been used by bookies placing and taking bets from all over the county, was exactly the way it had been left in 1950 when the races stopped. The walls were lined with chalkboards that had names and numbers and dollar amounts written all over them. Tables filled with telephones were left with chairs askew, as though the bookies on the phones had just left the room for a few minutes. The need for alcohol during the days of Prohibition required a devious craftiness so police—those who were not paid off—would not find the hooch. Even today, contractors find copper vats built into walls they are tearing out for building renovation. In a time when segregation was the norm, there were separate houses of prostitution for whites and blacks. (Courtesy Hagley Museum and Library.)

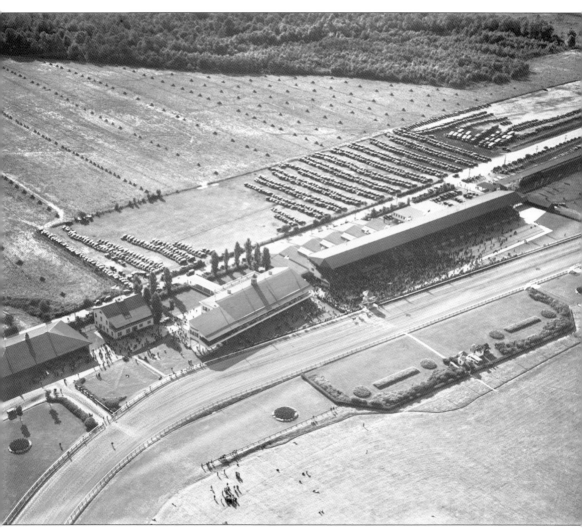

AERIAL VIEW OF HAVRE DE GRACE RACE TRACK GRAND STAND DURING RACES SEPTEMBER 29, 1931. The hotels in town were scenes of murder and mayhem. There is even a story that the noted criminal Arnold Rothstein invested in the track and fixed a number of the races so he could win. (Rothstein was shot in 1928, a few months after a three-day poker game. He owed $320,000 but didn't pay, saying the game was fixed.) On the other hand, the racing fans and bettors came from New York, Philadelphia, and Delaware—everywhere off-track betting was illegal. The tourist economy boomed. The local horse trainers did well. Pat Mergler tells of her husband's family. His dad was a trainer. His dad's father and four uncles were all jockeys and trainers in the 1920s and 1930s. (Courtesy Hagley Museum and Library.)

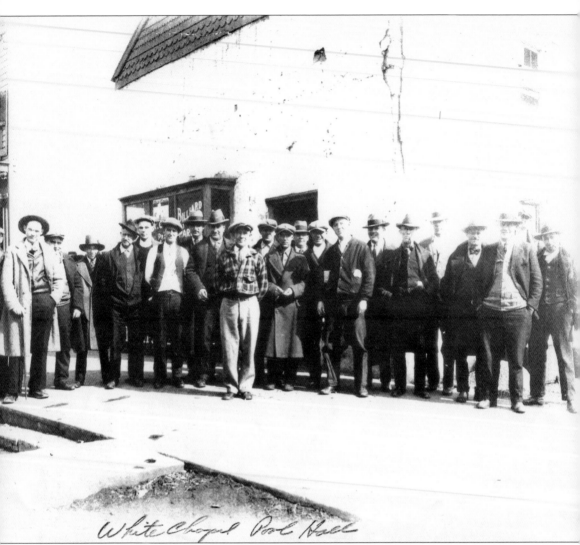

White Chapel Pool Hall

WHITE CHAPEL POOL HALL. On the northeast corner of Pennington Avenue and North Washington Street, the current site of Amanda's Florist, is the building glimpsed through the doorway in the barber shop on page 72. There is an earlier reference to a White Chapel Train Station at this location. The pool hall may have taken over that building at some point. There is no mention of a White Chapel before the train station. The only person identified in the photograph, taken supposedly in the 1930s, is the man in the center wearing a plaid jacket. He was known as "Mouse" Barnes—sounds like a character. (Courtesy the Historical Society of Harford County, Inc.)

Eight

CELEBRATIONS!

VELVET THE PONY. Every spring in the early 1950s, when this photograph was taken, a photographer walked the town, house to house, with his pony, Velvet. For the kids then, the appearance of that one pony was as exciting as the whole circus coming to town. The kids would sit on the pony, the photographer would snap their picture, and in a magic few weeks, the family would have the photograph in a frame on the wall, or in that special spot on Mama's dresser, or maybe in the store behind the cash register. Family pride ran high with the families in town. Maybe it had something to do with pride in continuing one's ethnic heritage. Maybe it was the hope that the new generation was going to have it better, be spectacular, and take care of the parents. Maybe so, but it sure wasn't something you saw in other towns around the county, where they weren't so heart-on-the-sleeve, where they weren't so—Havre de Grace. (Courtesy Brenda Baker.)

CUB SCOUT MEETING. Put a bunch of Cub Scouts and a camera in the same room together and you're bound to get a picture like this, no matter the year. Leading David Seibert's pack front and center in mugging for the birdie is current county executive David Craig. (Courtesy David Seibert.)

BAKER CHILDREN AT O'NEILL MONUMENT, CITY PARK. Brenda and her brother sit dutifully at the John O'Neill monument when it was still in City Park and before the park's name had been changed to Millard J. Tydings Memorial Park. (Courtesy Brenda Baker.)

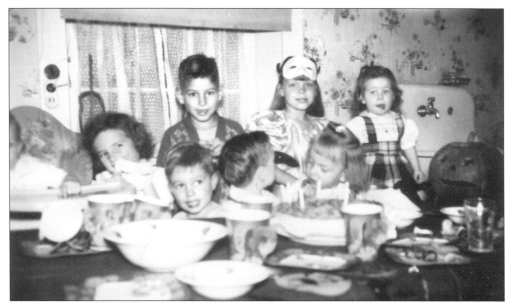

BIRTHDAY PARTY ON HALLOWEEN. A party at the Brennans' house combines the October birthday of two-year-old Leo with Halloween. The expressions are priceless, especially the little girl on the far right, who seems to be the only one noticing the cake. Note the one-spigot faucet on the kitchen sink. (Courtesy Brenda Baker.)

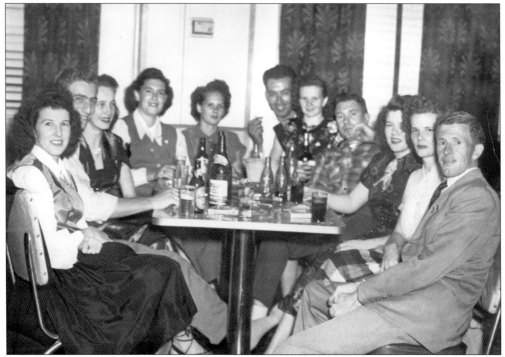

NIGHT CLUB. On summer nights, the music from the jukebox or live band would ooze out the screen doors. Kids, who had to endure the cousin babysitting them on a Saturday night and Mom and Dad dressed up to go out, fell asleep to faint notes drizzling into the open window. (Courtesy Brenda Baker.)

SANTA AND CHILD. Baby David Seibert sits on Santa's lap in Leon Levy's store. Pictures with Santa were a yearly ritual, like leaving a treat for Santa on Christmas Eve, although, in Nikki Languis's home on Juniata Street, "We never, ever left milk and cookies for Santa Claus. . . . In our house, Santa must have been Italian because we left him pepperoni and cheese instead!" (Courtesy David Seibert.)

ALL I WANT FOR CHRISTMAS. Brenda Baker recalls the must-have toys that she and her brother wanted in the early 1950s. Every girl wanted a Bonnie Brae doll, one of the first dolls to drink milk and then wet her diaper. Every boy wanted a Howdy Doody doll, just like Howdy Doody on television. (Courtesy Brenda Baker.)

Toyland–6th Floor

The American Toy Store

The grand, glittering, sparkling array of Toys and Dolls in Toyland this year is a sight over which even grownups are enthusing and a characteristic feature is everything shown is American made and the skillful way the things are made shows the Yankee adaptability to unmistakable advantage

Although our assortments now are very extensive and complete we advise selections without delay inasmuch as it will be impossible for us to duplicate orders in many instances.

Selections Made Now Will Be Held and Delivered When Desired

A few suggestions

A B C Blocks	25c to 98c	Horse and Wagon	39c to $3.98	
American Flyer Trains	98c to $3.98	Humpty-Dumpty Circus	75c to $4.98	
Automobiles	$5.98 to $35.00	Iron Toys	59c to $7.98	
Beaver Beasts	98c	Lead Soldiers	50c to $3.50	
Bell Toys	50c to 98c	Painting Outfits	25c to $2.98	
Children's Chairs	69c to $4.50	Rolly Dollys	25c to 98c	
Christmas Stockings	25c to $1.50	Sandy Andy's	50c to $1.00	
Christmas Trees	50c to $5.98	Shoo Flys	$2.50 to $4.50	
Dolls	50c to $15.00	Stuffed Animals	50c to $7.98	
Doll Beds	50c to $2.98	Ten Pin Sets	25c to 98c	
Doll Carriages	98c to $15.00	Tinker Toys	50c	
Doll Trunks	$1.50 to $4.50	Tool Chests	50c to $10.00	
Drums	25c to $1.75	Toy Dishes	10c to $5.00	
Electric Trains	$2.98 to $7.98	Toy Pianos	50c to $10.00	
Express Wagons	25c to $15.00	Tricycles	$7.50 to $17.98	
		Velocipedes	$3.75 to $17.00	
Games	25c to $5.98	Wheelbarrows	39c to $1.39	
Horns	25c to $1.00	White Enamel Doll Furniture	98c to $7.98	

If our merchandise and service satisfy you, tell others. It not, tell us.

If our merchandise and service satisfy you, tell others. If not, tell us.

In Connection With James McCreery & Co., New York.

CHRISTMAS ADVERTISEMENT, STEWART'S DEPARTMENT STORE. In 1901, Louis Stewart bought the Posner's Department Store building at Howard and Lexington Streets, and a Baltimore tradition was born. The toys in this 1930s advertisement seem expensive for a town struggling to come out of the Depression. But even those without money had love, and every Christmas Eve, kids listen for the jingle bell sounds that mean Santa is at their house. Nikki Languis writes about that time, when she and her sister listened: "Shela and I still laugh about it every year. And we know that the jingle jingle jingle sounds that we heard was our Dad, standing out on the back porch, shaking the bells, right under our bedroom window. And we know he would have been smiling all the while, because he knew we were up there listening, waiting for Santa's sleigh. He was doing it on purpose. He was doing what had to be done. He was making magic and memories for his children. He was a good man, my father." (Courtesy the Historical Society of Harford County, Inc.)

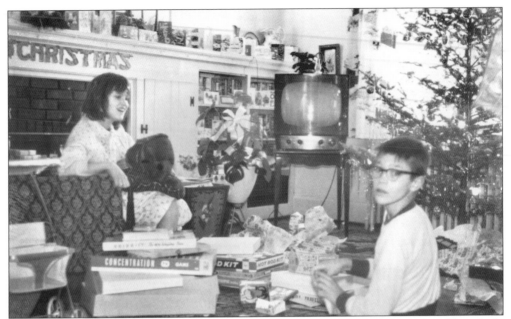

CHRISTMAS MORNING. Remember going back to school ("See ya in a whole year!") and everybody excitedly asking, "Wha'd'yaget?" David got a Concentration game, a Have Gun, Will Travel game, a hot rod kit, and some other stuff. And his sister got a huge stuffed puppy dog—or is it a bear? (Courtesy David Seibert.)

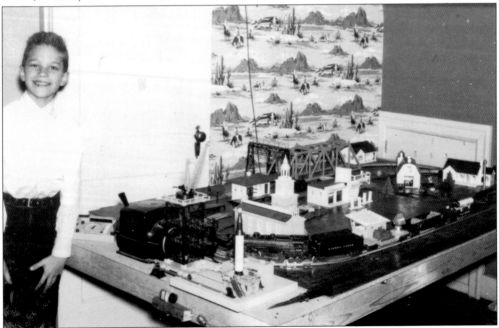

CHRISTMAS TRAIN GARDEN. Whether it was under the tree or up on a platform, the train garden was the neatest thing. Chances are your dad had to keep showing you how to run the trains, just so you'd get the idea. And two hours later, when you came in from playing in the snow, he'd still be there, hand on the transformer, dreaming about holidays with his old man. (Courtesy David Seibert.)

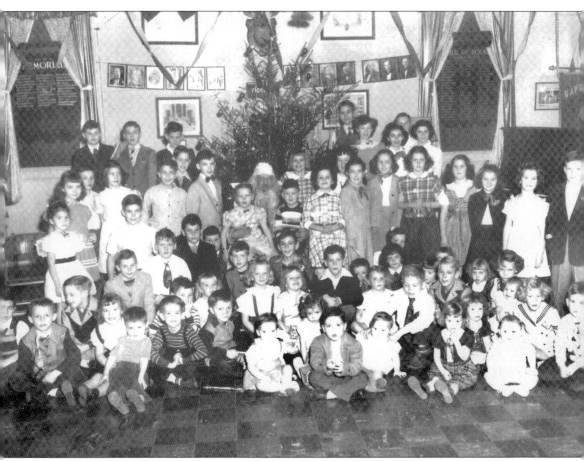

CHRISTMAS AT ELKS CLUB, 1949. An orange, a box of candy, and a pair of shoes—that's what the Elks gave each of the poor kids in town at a special Christmas party. In the summer, the Elks gave the kids sneakers and a trip to summer camp. Here's another Christmas memory from Nikki Languis: "When my sisters and I were little kids living on Juniata Street, Christmas was one of the happiest times of the year, and it was so exciting! We didn't have a lot of money back in those days so there weren't a lot of presents. What I remember most is coming down the stairs on Christmas morning, and seeing that tree! Oh it was so beautiful! Lights, pretty bulbs, and always angel hair. One year, my sister, Jo Ann, made tears well up in Daddy's eyes when she came down the stairs, saw that tree and exclaimed in childlike wonder, 'I wish every day could be Christmas!' He recalled that moment often through the years, and it always brought a tear to his eye when he told that story." (Courtesy Glenn Higgins.)

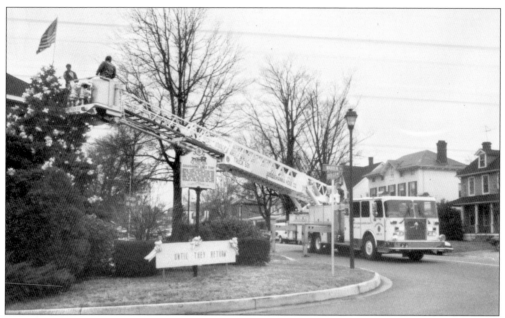

DECORATING THE TREE AT ST. JOHN STREET AND UNION AVENUE WITH YELLOW RIBBONS. To express solidarity with the fighting men and women during the First Gulf War, the town put yellow ribbons on the town tree for remembrance. Firefighters use Susquehanna Hose Company Truck 531 to reach high into the tree. The tree fell over in a strong wind in 1992. A statue honoring the Marquis de Lafayette was placed there. (Courtesy Richard Tome.)

RUNNER CARRYING OLYMPIC TORCH. Before the Atlanta Summer Olympics, the Olympic torch was carried from Mount Olympus in Greece, traditional home of the athletic contest, throughout the world, and to the United States. On its way to Atlanta, the torch was carried through Harford County, making its way through Havre de Grace, as seen here. (Courtesy Richard Tome.)

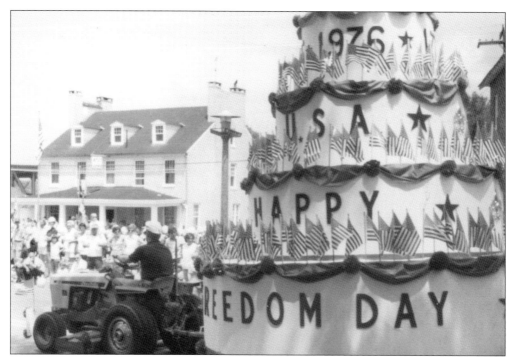

AMERICAN BICENTENNIAL PARADE. As many communities throughout America did, Havre de Grace held a Fourth of July parade that bested a proud tradition of parades, as the size of this huge celebration cake testifies. (Courtesy Richard Tome.)

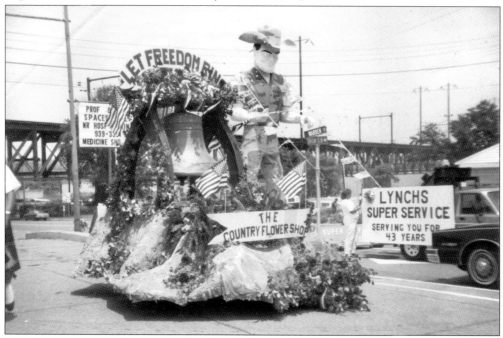

FOURTH OF JULY PARADE. A Roadside America icon from Route 40's golden age, the Giant Muffler Man from Lynch's Super Service on Route 40 gets a makeover as a First Gulf War soldier. (Courtesy Richard Tome.)

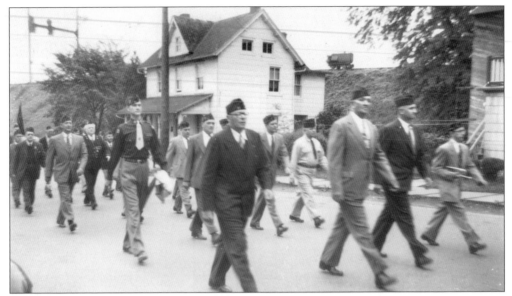

FOURTH OF JULY PARADE. The American Legion holds a special place in Havre de Grace. Before the town had its own EMS team, the Legion supplied an ambulance corps for rescue operations and medical emergencies. (Courtesy Brenda Baker.)

FOURTH OF JULY PARADE. The parade started on Juniata Street and proceeded up to the high school at Juniata and Congress Streets. As Cathy Vincenti says, "the parade has always been for us, the people who live here, not as a show for tourists." It is a pure expression of patriotism and hometown pride. (Courtesy Brenda Baker.)

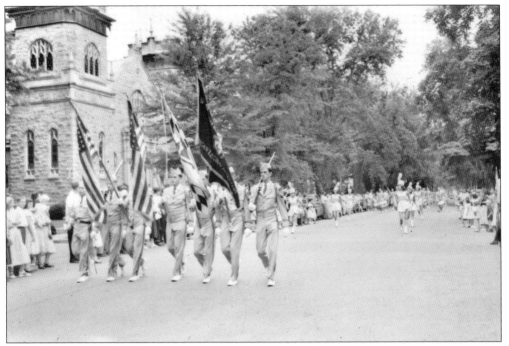

FOURTH OF JULY PARADE. The closeness to Aberdeen Proving Ground and Bainbridge Naval Institute gives Havre de Grace a special tie to the army and navy. (Courtesy the Historical Society of Harford County, Inc.)

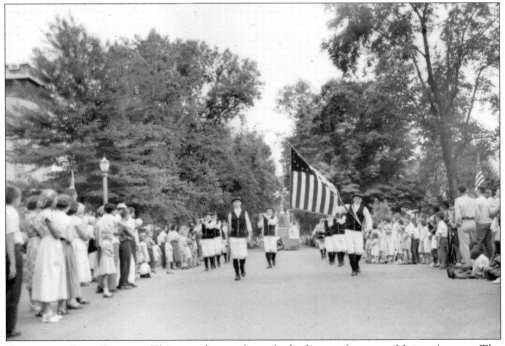

FOURTH OF JULY PARADE. This parade ran through the heart of town at Union Avenue. The Methodist Church is in the background on these two snapshots. (Courtesy the Historical Society of Harford County, Inc.)

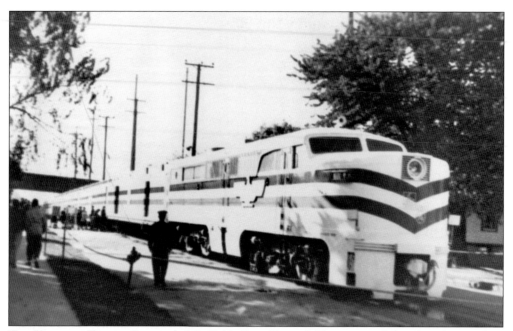

THE FREEDOM TRAIN, OCTOBER 26, 1948. Pres. Harry S. Truman used the idea of a traveling show to rev up American ideals in the post-war years. The train carried original versions of the U.S. Constitution, Declaration of Independence, and Bill of Rights. It was the first train to visit all 48 contiguous states. The last public display was in Havre de Grace. (Courtesy the Historical Society of Harford County, Inc.)

THE FREEDOM TRAIN'S LAST STOP. At its last stop here on Juniata Street, the longest train tour in history had traveled 34,916 miles since its first public showing in Philadelphia on Constitution Day September 17, 1947, and had given 355 shows in 313 stops in all 48 (then) states to 3,068,869 citizens. (Courtesy Glenn Higgins.)

HANDS ACROSS AMERICA, MAY 25, 1986. A special image of community celebration appropriately concludes this book. Hands across America was a benefit event staged on May 25, 1986, in which millions of people held hands for 15 minutes along a path across the continental United States. Participants paid $10 to reserve their place in line; the profits were donated to local homeless charities. This photograph captures the heritage of Havre de Grace with the Lock House and Susquehanna River in the background. It reveals a moment of happiness when residents of all ethnic and class backgrounds embraced hands in unity, and it brings a vision of hope to remind us all that, even in our current time of big changes for the little city by the bay, it is the people who have built this city with their heritage, their happiness, and their hopes. They have made the city what it is, and they will make it what it will become. (Courtesy the Historical Society of Harford County, Inc.)

ACROSS AMERICA, PEOPLE ARE DISCOVERING SOMETHING WONDERFUL. *THEIR HERITAGE.*

Arcadia Publishing is the leading local history publisher in the United States. With more than 4,000 titles in print and hundreds of new titles released every year, Arcadia has extensive specialized experience chronicling the history of communities and celebrating America's hidden stories, bringing to life the people, places, and events from the past. To discover the history of other communities across the nation, please visit:

www.arcadiapublishing.com

Customized search tools allow you to find regional history books about the town where you grew up, the cities where your friends and family live, the town where your parents met, or even that retirement spot you've been dreaming about.